Werner Bischof

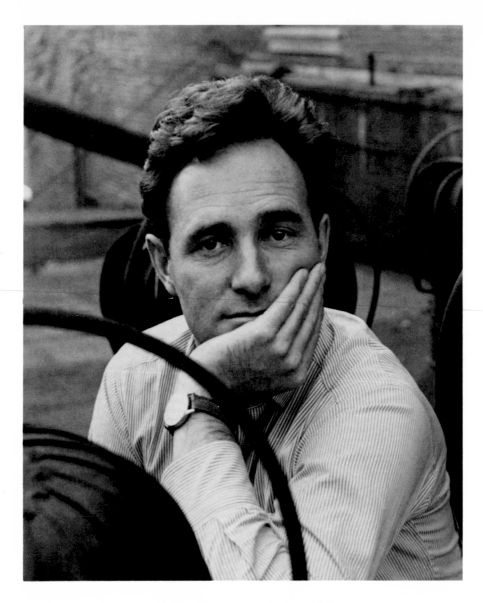

Werner Bischof, New York, 1954
by Erich Hartmann

ICP Library of Photographers

Werner Bischof

1916–1954

GROSSMAN PUBLISHERS
A Division of The Viking Press
New York 1974

ICP LIBRARY OF PHOTOGRAPHERS

Series Editor
CORNELL CAPA

Series Associate Editor
BHUPENDRA KARIA

ICP—the International Fund for Concerned Photography, Inc.—is a nonprofit educational organization. Established in 1966 in memory of Werner Bischof, Robert Capa, and David Seymour—"Chim"—ICP seeks to encourage and assist photographers of all ages and nationalities who are vitally concerned with their world and times. It aims not only to find and help new talent but also to uncover and preserve forgotten archives, and to present such work to the public. Address: 275 Fifth Avenue, New York, N.Y. 10016.

ACKNOWLEDGMENTS

Our grateful thanks to Rosellina Bischof Burri for translating and making available selected letters from the voluminous correspondence of her late husband, Werner Bischof. All letters are addressed to Rosellina Bischof unless otherwise noted. This material has never been published in English before.
Thanks and appreciation are also due to the staff of Magnum Photos, Inc., New York and Paris, for their devoted assistance.

Vol. 2: WERNER BISCHOF

Editors
ROSELLINA BISCHOF BURRI
RENÉ BURRI

Editorial Consultants
INGE BONDI
YVONNE KALMUS
ROBERT SAGALYN

Research Assistant
LAURIE SAGALYN

Design
ARNOLD SKOLNICK

Copyright © 1974
by the International Fund for Concerned Photography, Inc.
All rights reserved
First published in 1974
in a hardbound and paperbound edition
by Grossman Publishers
625 Madison Avenue, New York, N.Y. 10022
Published simultaneously in Canada
by Fitzhenry and Whiteside Limited
SBN 670-75717-9 (hardbound)
670-75718-7 (paperbound)
Library of Congress Catalogue Card Number: 73-14141
Printed in U.S.A.
by Rapoport Printing Corp., New York City

Contents

A whole generation of young photographers has grown up on the ideals of Magnum—ideals pursued by some of the most respected photographers: Robert Capa, Henri Cartier-Bresson, Werner Bischof. Each of these men brought to photography, and to their undying brotherhood, separate and distinct virtues and disciplines.

Robert Capa's legendary courage has inspired innumerable war photographers to take their camera close enough to action; Cartier-Bresson's preoccupation with geometry and decisive order has become a living tradition; and Bischof's quiet, deep sensibilities and formal mastery are held exemplary by all those who have experienced the tyranny and isolation of the ivory tower of art.

Photographers celebrated by the mass-circulation magazines and the print media tend to become depersonalized by the slotting and compartmentalizing that accompany popularity: Capa's courage, Bischof's beauty. We tend to focus on a part and soon begin calling it the whole.

Here we wish to concentrate on the whole man, his achievements, his hopes, despairs, transformations, and growth. Thus Robert Capa's compassion for the downtrodden and the desolate, his universality in an intense desire for justice and peace among mankind, and Bischof's gradual disenchantment with art for art's sake, combined with his growing preoccupation with the human content, are vital counterbalances to their popular images.

Instead of revolting against art, Bischof created a gentle revolution through his art. Extending his innate and acquired sensibilities to the larger world around him, he became an artist-commentator. He went forth from his tidy Swiss world to become a greater human being rather than a great artist. This book tells, for the first time, in Bischof's own words, of the struggle, the turmoil, the intensity, and the drama of a man who transcended art to make simple and powerful statements on the human condition. His pictures impart a dignity to the suffering, urge compassion from the complacent, and command vision from the unseeing.

When gentleness and courage come together, a nurturing wellspring breaks through. Capa was that wellspring. When an all-pervading awareness sprouts through the rich soil of art, a flowering tree is born. Bischof was that flowering tree.

Bhupendra Karia, 1973

Had Werner Bischof been born at another time, before the invention of photography, he would have realized his gifts in some other medium. It is easy to imagine him doing delicate, carefully executed silverpoints of plants and fruits on precious paper, or engraving animal images in stone in the ancient manner of the lapidary. But instead of pencil and burin, he works with light and shadow, catching the subtlest possible shadings with his camera's crystal eye. Or, properly speaking, did so in the past, for these photographs which Werner Bischof submits to the connoisseurs of the beautiful are not only the summation of his skill, but also a conclusion and a farewell. The man who ground and polished the shells for hours in order to obtain the desired degree of translucence, who understood the means with which to render the subtlest light and shade, who investigated—as every poet and dreamer did—the most delicate and fragile of objects, one day pushed aside everything he knew and had achieved, got in a jeep, and drove off into the world laid waste and despoiled by war—to Germany, to Holland, to Northern Italy. To photograph. To make a new statement.

Manuel Gasser, 1946

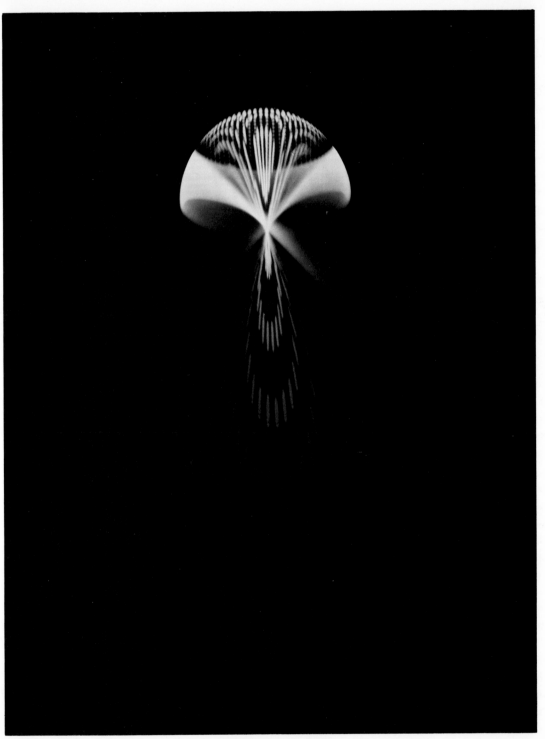

Reflected light, 1936

GERMANY

A Journey to Austria and the South of Germany (French-Occupied Territory)

September 5, 1945

Almost four months after the end of the Second World War, I had my first opportunity to leave Switzerland. I could go to Austria and Germany. The first questions that came up were, naturally, what to take with me and how to solve the transportation problem. From an article I had just read I gathered that it would be best to prepare as if going on an expedition. And that is how I prepared myself, as if there were no hope of obtaining anything. I traveled by bicycle, carried a rucksack, a small suitcase, and some warm clothes, leaving the mainland on the fifth of September at St. Margrethen.

The last time I was here thousands of refugees were waiting at the border. Now all was emptiness. On this foggy morning only the gray, wide waters of the Rhine moved slowly under the bridge. Already from afar I recognized the white turbans and brown heads of the Moroccans. Three of these lonely, dazed men lean against the toll-bar and one is at the customs house. No movement. Only dark big eyes. And then a turn of the head toward the window of the customs house. A Negro, tall as a tree, takes the passport from my hands. He does not seem to see me; just hums to himself a nostalgic-sounding melody, something like the music we hear on Radio Algeria. I pedal on through Höchst. Moroccans everywhere. A woman who has certainly seen better days begs her way from farm to farm. She is a refugee, she says, searching each day for something to eat.

I arrive at a big bridge, guarded by a military post. Two Moroccan soldiers are stretched out on a wall. I want to show my papers. With a big effort one of them mutters: "Cigarettes!" "*Voilà,*" I give each of them a cigarette and it is possible to pass without documents. This is my first contact with the "international currency." Shortages are everywhere; only the Americans have none. The next village is Hard, near Bregenz. Huge ruins of big barns: full of hay, but without walls. German prisoners squat everywhere. Barracks with primitive cooking facilities, barbed wire all around, and watchtowers with machine-gun posts. I say "*bonjour*" to the soldier who comes toward me. Cigarettes are not enough for him. I ask if I may enter the camp. No, I would have to ask the commanding officer, and he is not here. So I pedal along the busy street, past the big French barrack encampment, past huge posters on the walls—the propaganda of the liberators. Groups of German prisoners of war, with PW imprinted on their backs, clean the streets under Moroccan supervision, very slowly, as if in a daze.

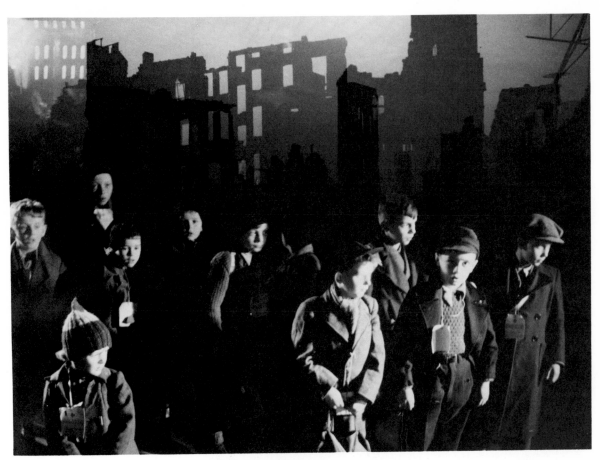

Refugee children (montage),
Germany, 1945

Colonel J., who helped me with my travel permit, receives me at headquarters. Inside there is a great deal of talking and flirting. Nobody is overworked. Leaving my bicycle and belongings in this well-guarded building, I walk through the streets of the little town with my camera. There is nothing to be bought in any of the stores. The few restaurants that are open are so crowded there is hardly room to stand. I opt for eating at headquarters, as guest of the French commanding officer, at the well-provided table of the victors. The food: toast, bread, white wine, red wine, sweet apple juice, appetizer, salad, vegetables, meat, cheese and butter, dessert, coffee, liqueurs. Not bad compared to the usual pot of weak stew and watery soup that the people around us ate.

The only accredited photographer in town was obliged to shut up his shop in 1943. The Germans terrorized him. His shop was ravaged, but in his old ruined house he still has a pretty large supply of film and other photographic material hidden away. He is interested in Swiss money and I in film, so we strike a mutually satisfying bargain.

My little suitcase was dead weight. In return for cigarettes the cook has agreed to safeguard it for me. I have also promised him a repair kit for his cycle if I get all my stuff back.

At Lindau I saw a big prisoners' camp and a lazaret of Italian soldiers. A guard suggests that I hide my cameras, otherwise I will be arrested at once. One sees military equipment all over the camps and in the wide fields around us. In town the shops are empty. Then, further along the road, toward Friedrichshafen, past great forests, battered, overturned cars are lying along the road. Today I still see them, but later they will be so numerous that I'll probably notice them again only when they are gone.

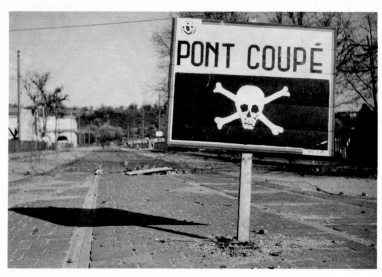

"Bridge Out,"
Southern Germany, 1945

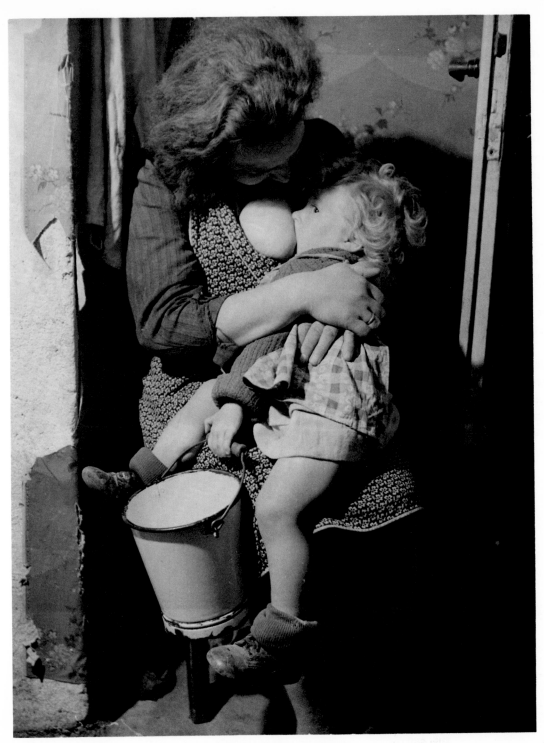

Cologne, Germany, 1946

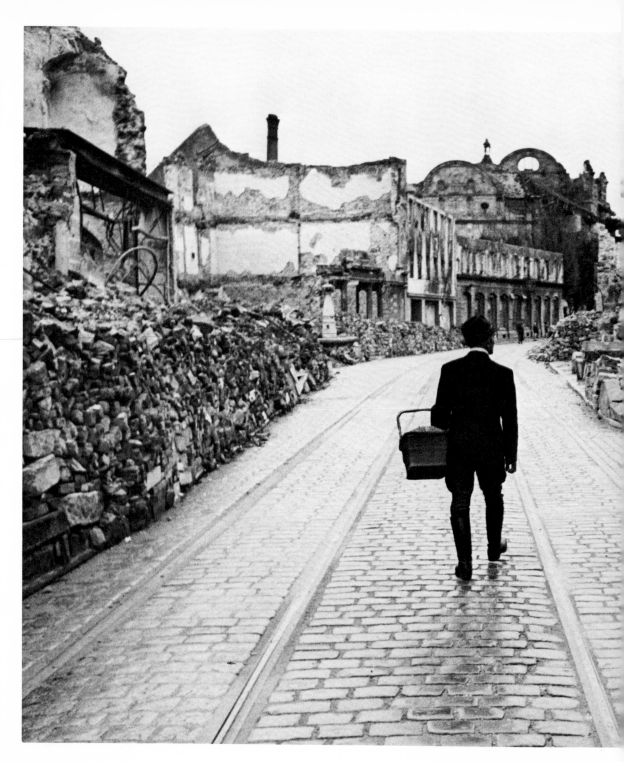

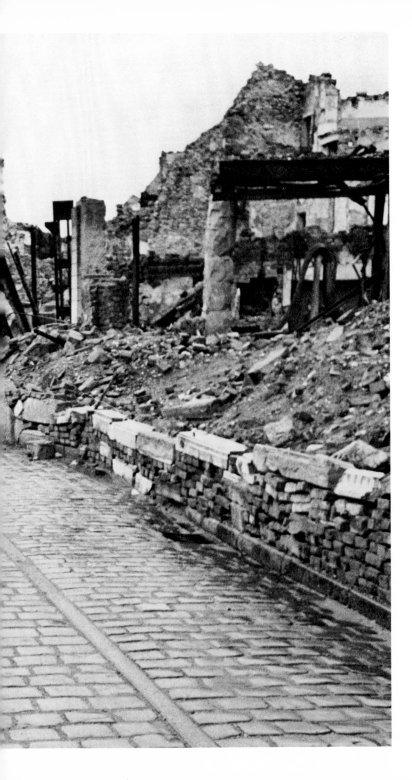

Germany, 1945

EASTERN EUROPE

In 1947 and 1948 Werner Bischof traveled
for many months in an old car through Eastern Europe. At that
time such a trip from Bucharest to Helsinki was not without
danger, difficulty, and hardship. His was a journey without any
official mission, a roaming at random open to all inspirations,
and he was on the road trying to understand.

So many contradicting opinions and reports
came from these countries that our friend wanted to search out
his own truth and find his own way—passing through land-
scapes and talking to people who were living under these sud-
denly changing socio-political circumstances.

—Arnold Kübler, 1949.

Budapest December 1947

It is Christmas Eve. In front of the gray, windowless walls of the large
internment camp in Budapest, hundreds of women wait for their names to
be called so they can personally deliver a small gift to their imprisoned
husbands and sons. For months and years two thousand people have lived
behind these walls because they differ with the government.

I have come here with a SWISSAID delegation, but we have to regard
the commander's granting us permission to enter and distribute food as a
great favor. Behind the barred windows of the big barracks the prisoners
are pressed man to man, and hundreds of pairs of eyes follow our free
strides. Walking through a narrow, heavily guarded passageway, we enter
a square inner courtyard covered with snow. Solitary dark figures begin to
move like raindrops, trudging through the wide square, crisscrossing it with
black footprints.

Later they gather in their barracks rooms around a little tree, about
fifty men of various ages who are interned for nobody knows how long. They
sing a Christmas carol; an old peasant begins to cry. There they stand,
singing, and somewhere outside the wall their families are waiting. . . .

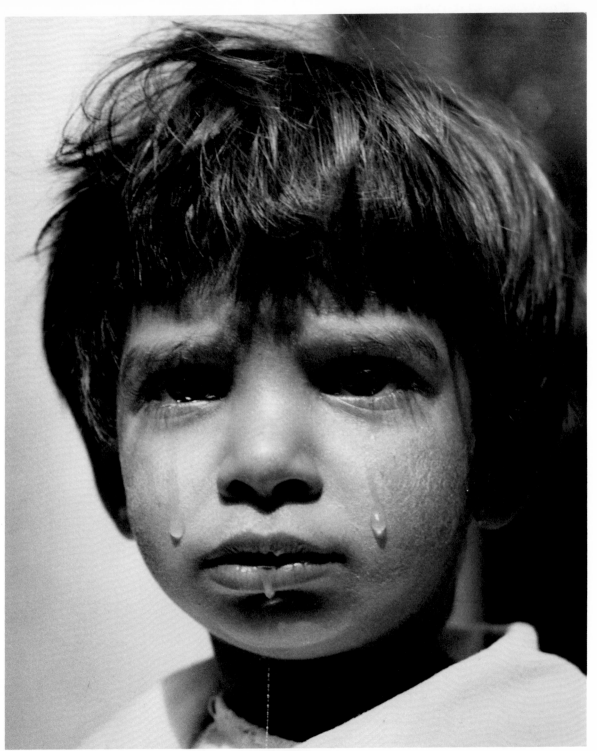

Hungary, 1947

Eastern Hungary December 1947

The sudden warm weather of the last few days melted great masses of snow in the Carpathian Mountains. As a result the river Tisza rose over four meters and the badly maintained dam in the Ukraine burst. An area where about three thousand people live was flooded before some of the inhabitants could save themselves. Then the frost came, and the flooded area turned into ice. It is snowing as we cross the bridge spanning the Kölcse Canal, and traveling over an icy road we reach Tiszabécs. We pass houses in a state of collapse. A dead cat, golden-yellow corn, chairs, beds are lying about frozen and ruined. Frightful misery has come to these already poor villages.

 For the neediest children we carry a few sacks of warm clothes with us. Meanwhile, in Budapest, conferences are being held to plan emergency measures. News of a second break in the dam at Tivadar worsens the situation considerably. The number of homeless mounts to ten thousand now. The farmers of the neighborhood have sent wagonloads of food over to Mátè Szalka. I accompany a shipment of bread from Vásáros Namèny across the Tisza. The army has set up a crossing here, an emergency boat operation. A troop of men with spades over their shoulders is marching toward us in formations of six. This is the left-socialist storm brigade from Budapest. The inhabitants of the small village watch this propaganda game. At 9:00 p.m., after three hours of work, the party from town retires to the schoolhouse to spend the night. But toward midnight the angry farmers chase them out of bed. On Sunday the newsreel crew and the press appear. For days they glorify the devoted work and selfless response of this brigade. As if conditions are not bad enough, the poor community must now feed them also.

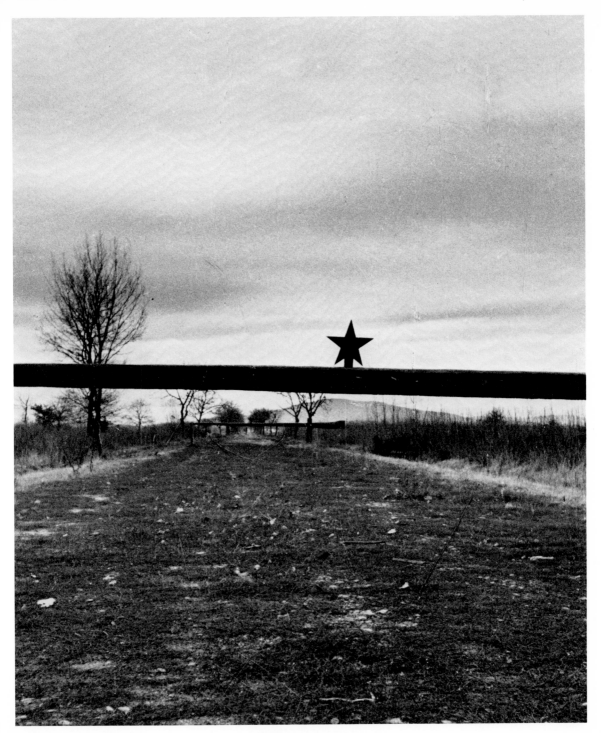

Hungary, 1947

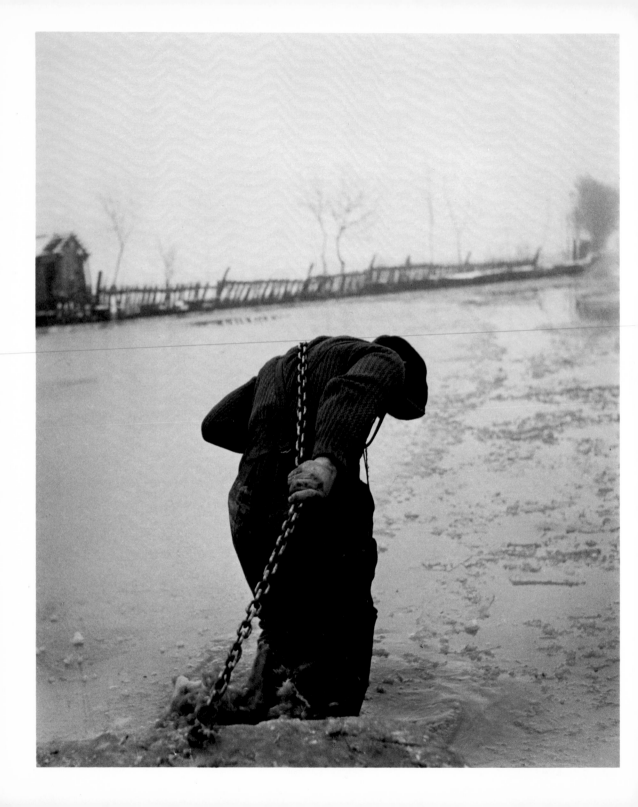

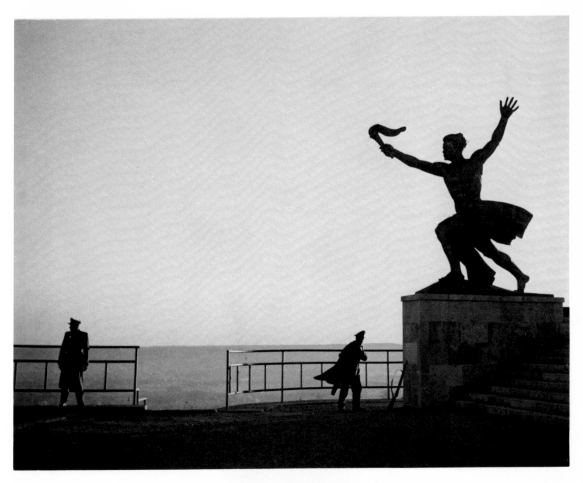

Budapest, Hungary, 1947

Flood of Tisza River,
Hungary, 1947

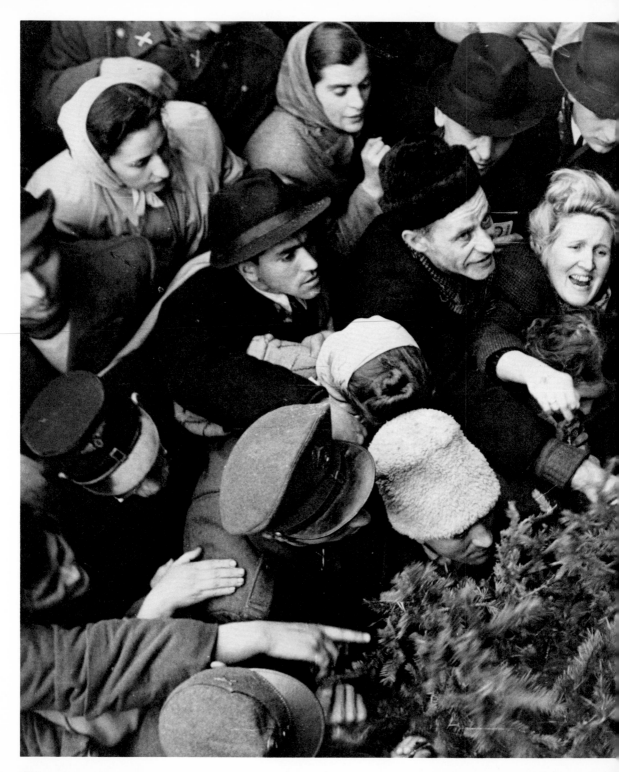

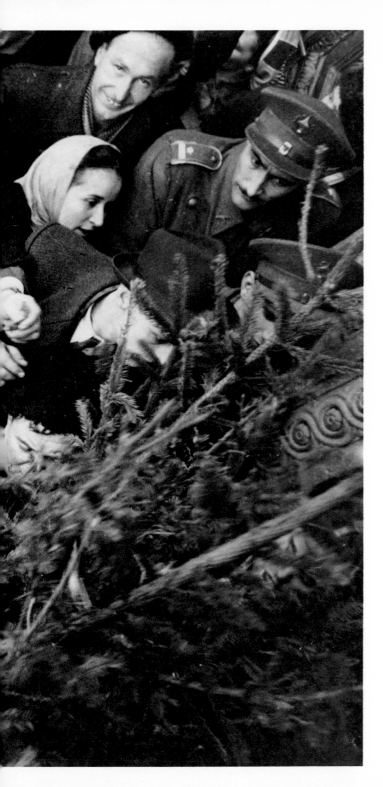

Fight for a Christmas tree,
Budapest, 1947

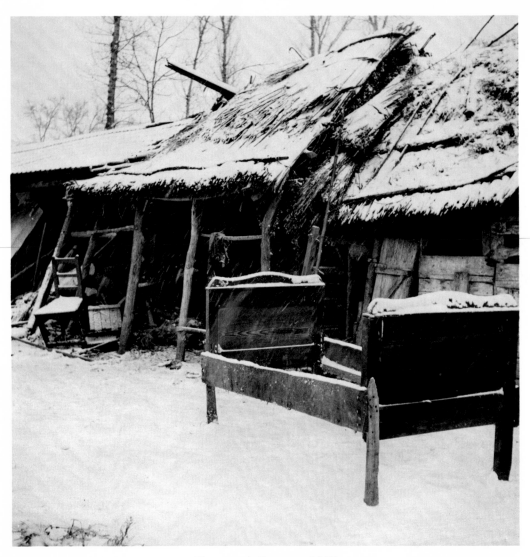

Tiszacorod, Hungary, 1947

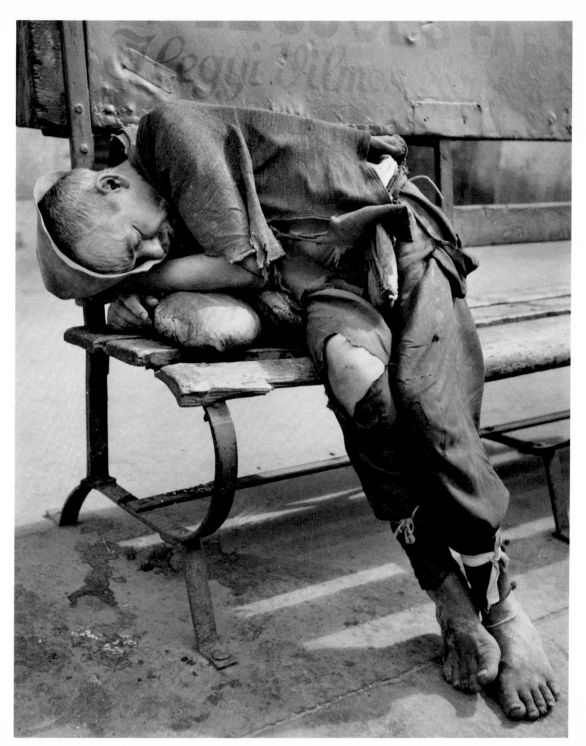

Budapest, 1947

Helsinki September 1948

. . . I have yet to make a big decision. I have the Magnum contract in hand.
This is an agency (organized on a cooperative basis) of photographers—
the best in the world—Capa, Cartier-Bresson, Chim, and Rodger. What is
important to me is that they are all sound people and socialist-inspired.
Two of them were in the Spanish Civil War. They are free people, too
independent to tie themselves to one magazine. So, if the movie plans
don't work out for now, I won't be unemployed. This way I could travel all
over the world, and you might enjoy that too. . . .

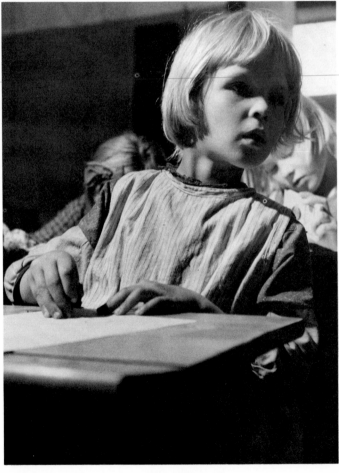

Schoolgirl,
Finland, 1948

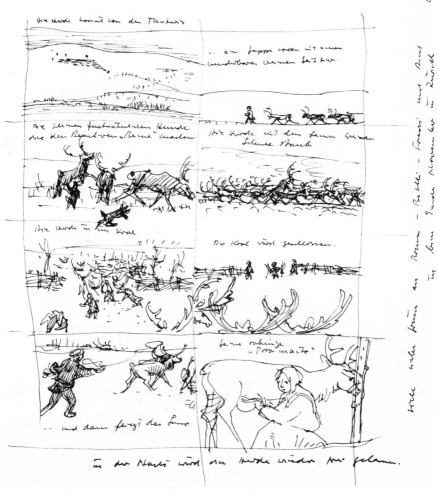

**Werner Bischof's
letter to Emil Schulthess**

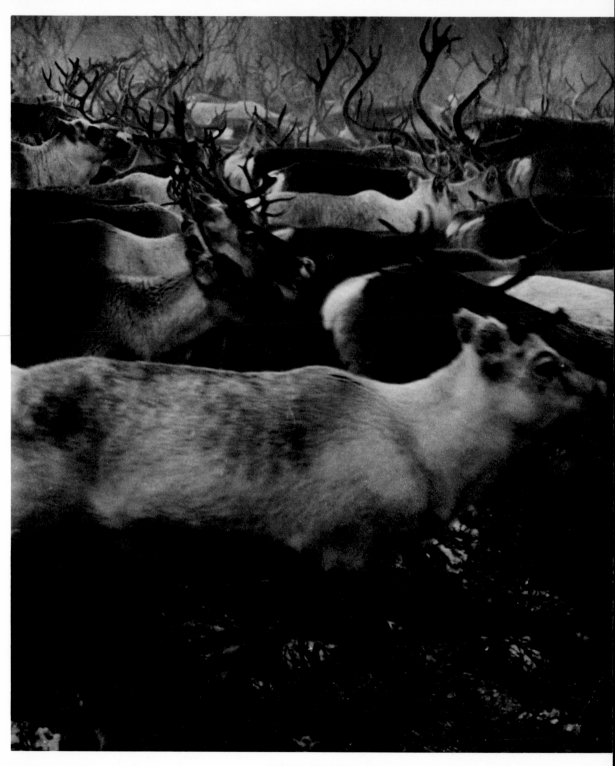

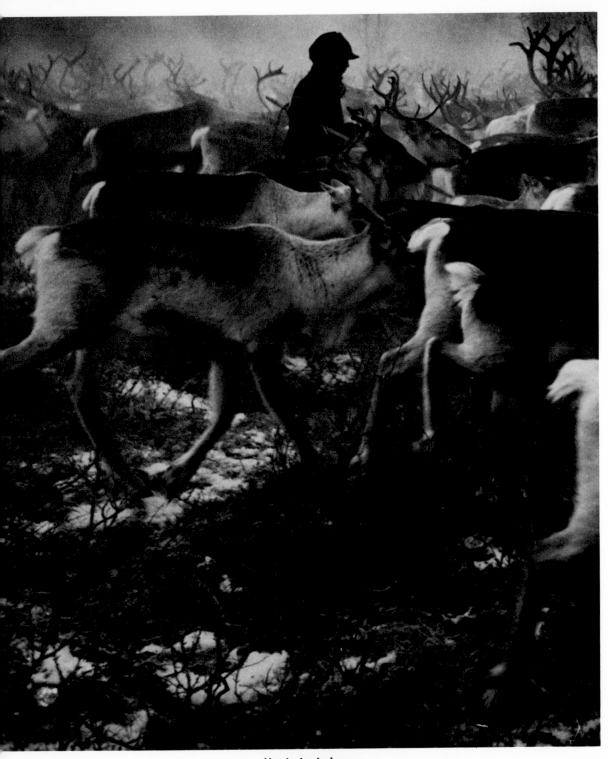

**Herd of reindeer,
Northern Finland, 1948**

ENGLAND

London April 27, 1950

. . . Thursday night. Capa returned to Paris today after we had a good long
talk. Sometimes he is like a father when one is alone with him. Today
Spooner, Capa, and myself had lunch and discussed many projects.
Tomorrow I am going to start my first story for *Illustrated.* They want me
to do a whole series for them. This first reportage will be on a hospital in
the East End of London. It is open twenty-four hours a day and all kinds of
people go there with all kinds of diseases and accidents. I am going to
concentrate on the Accident Department, and I want to try to describe the
contrast between the dark, sleeping city and the lit-up, helping atmosphere
of the hospital.

London May 6, 1950

These last five days and nights in the hospital were hard but worthwhile.
I have to try every resource to achieve powerful expressiveness for my
observations and have to be very severe in the choice of my pictures.
Then one day I would also like to make enough money to work on an
experimental film.

London June 25, 1950

Last night I printed in Michael Petö's darkroom until about 3:00 a.m.
There was also a second Hungarian from Paris, a painter and photographer
who takes beautiful, quiet pictures, and a third Hungarian who is studying
engineering in Zurich. Petö's wife cooked great food for us—real Hungarian.
Erwin thinks that a photographer who doesn't have something Hungarian
can't be good! Very shyly I asked if a Hungarian wife counts too. We laughed
a lot and now I feel somewhat better. We discussed many things and it was
really fine to talk "international" once again, especially now when the
political situation is becoming tense. Korea is on the front pages of the
press, and I am much preoccupied with this war. Although I saw it coming
sooner or later, I am very depressed by it and am wondering how the future
will shape up for all of us. Is it really impossible to subjugate this monster,
war?

Edinburgh May 21, 1950

. . . A lot has changed for me—I realized it yesterday when I visited an old,
very beautiful chapel. Great to look at, but to battle for hours with lighting
and tripod for the sake of these "dead" things doesn't interest me any
more. I would much rather stand about in a railway station and experience
the bustle, the comings and goings. . . .

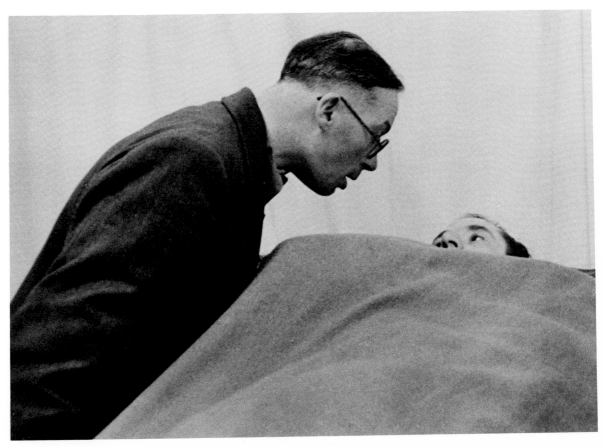

**Casualty station,
London Hospital, 1950**

INDIA

Alarming news of an impending famine throughout various provinces of India is spreading all over the world. Conflicting reports have continued to appear in the press. At the end of April I therefore determined to find out for myself.

The state of Bihar, north of the river Ganges, has the highest population density in India. It is estimated at 1,200 to 1,500 inhabitants per square mile. Here the ever-growing population aggravates other problems. Eighty percent of the population works the land. Because of drought they have had a poor harvest three years running and are helpless.

Report on My Trip to North Bihar

End of April 1951

The threat of famine is strongest in Muzaffarpur and Darbhanga, two provinces in Bihar, located between the river Ganges and the Nepalese border.

In a dramatic encounter with Mr. K. M. Munshi, Central Flood Minister, Bihar's Minister of Food, A. N. Sinha, threatened to resign unless the required grain was delivered to his famine-stricken province within the specified time. Mr. Munshi found himself in a great predicament: he did not have the needed grain at his disposal. Every day twelve hundred tons of grain were dispatched from the docks at Calcutta reach Mokameh, the harbor station sixty miles from Patna. There, since there is no bridge across the Ganges between Calcutta and Benares, four hundred miles upriver, the sacks of grain are slowly and laboriously reloaded onto narrow-gauge railroad cars, which in turn are shipped on barges across the Ganges River. It seemed to me the people were starving more quickly than the grain could reach them.

In the village of Dighiar, not far from Darbhanga, the inhabitants gather around us. Word of a European's arrival spreads like wildfire. The women and even the half-grown girls come to us and beg for food and clothing. *"Babu moré cho"* ("Sir, we are dying"), they call to us, especially the old, who are the first to be affected by famine. Skeletons covered with skin and veins, leaning on bamboo poles, waver toward us. An old man collapses in front of me. His eyes are crazed, he is trembling all over. He touches my shoes and looks heavenward. He has not eaten a bite in three days. Two of his family have already died and he has no strength for work.

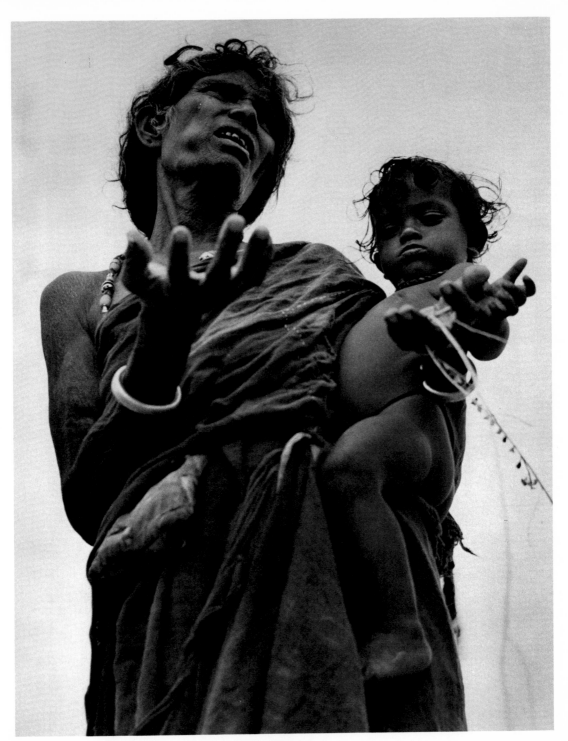

**Famine,
Bihar State, 1951**

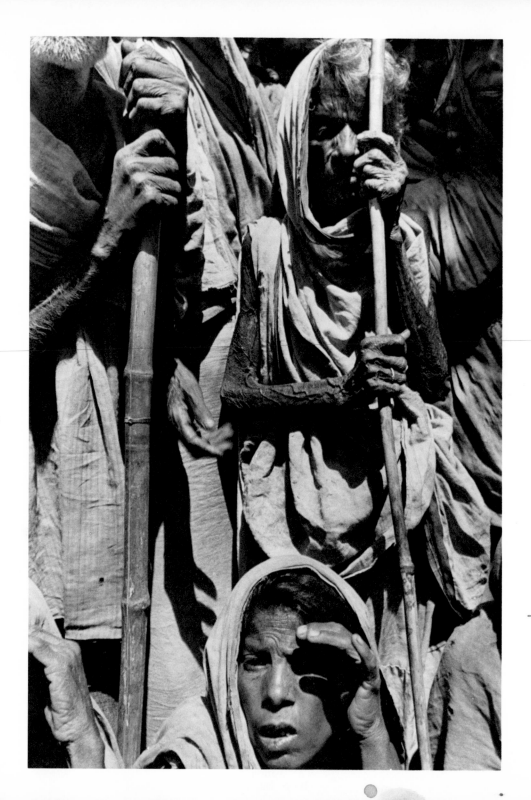

The middle-aged have the greatest reserves of strength and are for the most part employed in relief work. Many of the inhabitants do not have the twelve *annas* [then about thirteen cents] they need to buy the weekly ration of grain. It is therefore the task of the government to create some earning opportunities for the people.

Slowly the water reserves of the villages begin to fade. Once the bucket-wells have reached a critically low water level, they cannot be used anymore. The village ponds, covered with algae, have turned green. Man and beast alike bathe in them and drink from them. The soil in the fields has cracked and dried out. Women and children dig for roots with primitive tools. If luck is with them they may find a frog here and there in a dried-up pond.

In Ghutulli, another village, the picture is the same. The return from the sweet potatoes they planted last year was so poor the crop was hardly worth the sowing. The children have bloated stomachs, and malaria isn't always the cause. Two corpses lay in the street of one of these villages. The post mortem was: starvation. The stomachs of the dead contained leaves from the trees.

Over the endless dried-out plains roll the caravans of carts. Everything is covered with dust. Dust penetrates everything and makes breathing difficult. The great rivers are dried up, the mango trees give only a little shade——they are ringed with hungry animals.

Factories for processing rice have been idle for years; the machinery is rusting away. Nobody cares anymore. Thin as a rake, an old farmer with a long beard drives a pair of oxen ahead of him. He himself carries the wooden plough. I don't know what he has to plough——the soil is hard as a rock. Our jeep frightens him. He flees like some startled animal and we cover him in a cloud of dust.

In Devdhar the entire population has gathered at the ration supply center. Grain has arrived. There is enough for a week. Here, too, the old women beg the inspector for free food. All his explanations are useless. The people cannot understand that the government is unable to carry the enormous cost of supplying free food for all.

Eighty-seven percent of the population of India cannot read or write. The peasants have no concept of what is going on in the world. We ask one of those waiting for grain some questions. Has he ever heard of Gandhi or of Nehru? He hasn't. Does he know that the English have left India or that a country called America exists? Yes, he has heard people talk about such things. In view of the coming elections, we ask him if he knows what an election is; this he is unable to explain.

Bihar State

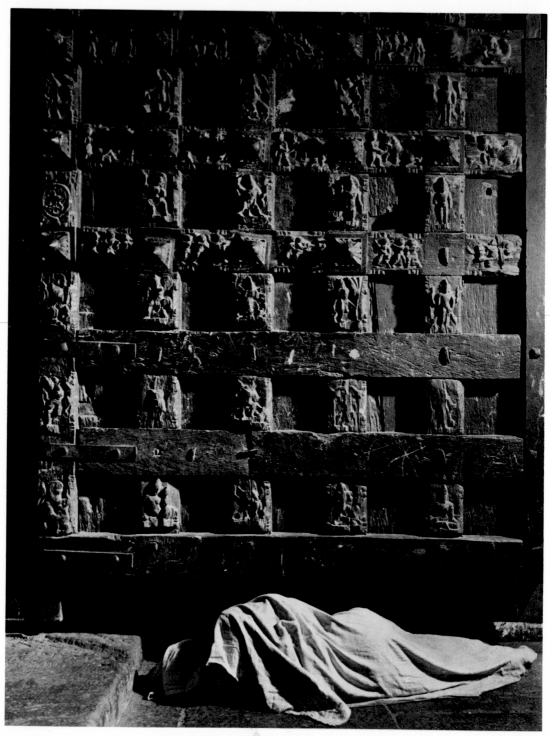

A beggar sleeping in front of a temple, Madras

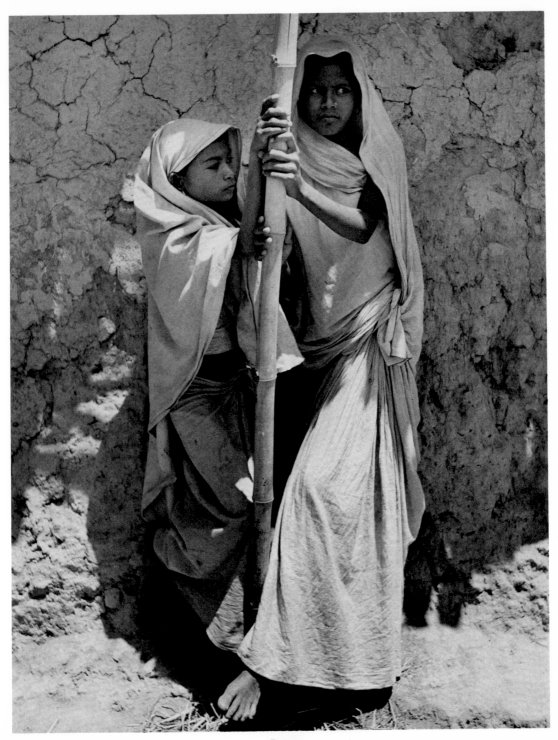

Patna

Calcutta May 6, 1951

. . . Capa wrote me a great letter: "Bischof, you have to relax now!" he tells me. He's getting too much Indian material from me and it is high time for me to vanish from this country. The magazines are "groaning" and cannot always publish articles about India. According to his last report, the Generation X project has now been definitely assigned and I have to fly to Japan quickly before the editors change their minds. Imagine, *Illustrated* is publishing the "Famine" story on seven pages, and *Match* has bought it too. I still have so much to see and say about India—even if the international market is glutted with Indian material. That doesn't mean that I have had enough. We must return here in winter. . . .

Calcutta June 26, 1951

These last few days I have been doing a great deal of thinking about my work in connection with this big trip. What my eyes see and what impresses me is worth recording, but not from a purely artistic point of view. The so-called "beautiful pictures" are often static, and in composing perfect photographs it is easy to fall into the trap of withdrawing from motley, moving life.

Today and here I see no justification for my journey unless I am completely committed to the present and to the problems of our time.

Fine, but why not photograph a positive human story beautifully? What motivates all the editors in the world to look for topical, dramatic pictures full of strong personal feelings? I watch myself reading the newspaper. First the headlines: "Oil Crisis," "Korean War," "Fighting in Burma." Then, on the next page: "Food and Overpopulation." Next, on the sports page: "Jaroslav Drobnik at Wimbledon." Then some news about delivery of grain to famine areas, transport difficulties, etc. All daily happenings that influence our development, that are related to our being or not being, move us. Then I pick up the newspaper, the magazine, a second time, and I notice well-written stories, new discoveries, cultural developments, and I try to put all this in perspective.

The question is: should I not leave this to the politician or to the news reporter? I believe we have the obligation to grapple with the problems around us and to do so with severe concentration and evaluation, in order to form the image of our generation. In the course of my own development I have to make many things clear to myself. It is a necessity for me to ask myself these questions, and I would like to know your thoughts.

Wheat arriving at port,
Calcutta

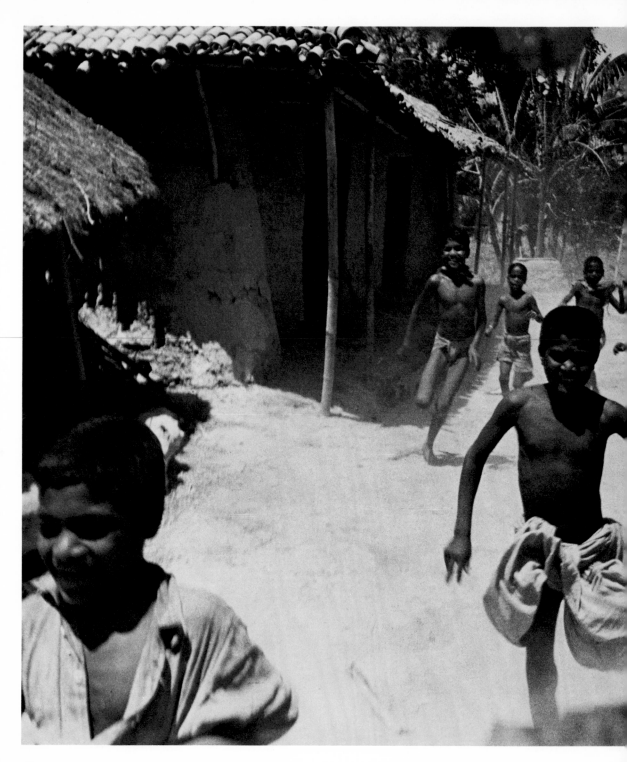

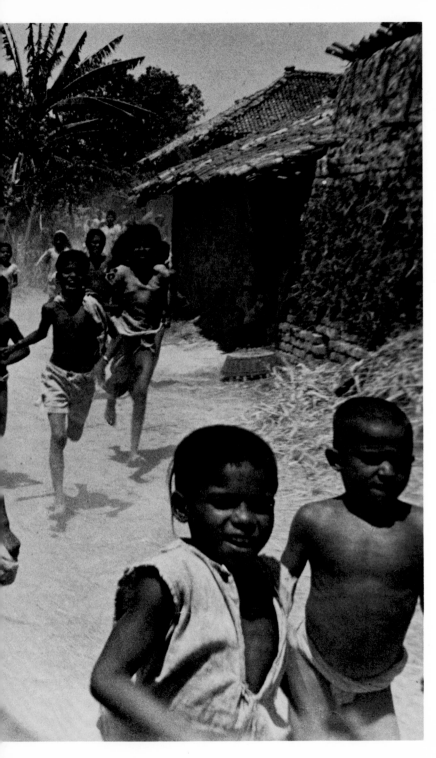

**Food arrives at the village,
Bihar State**

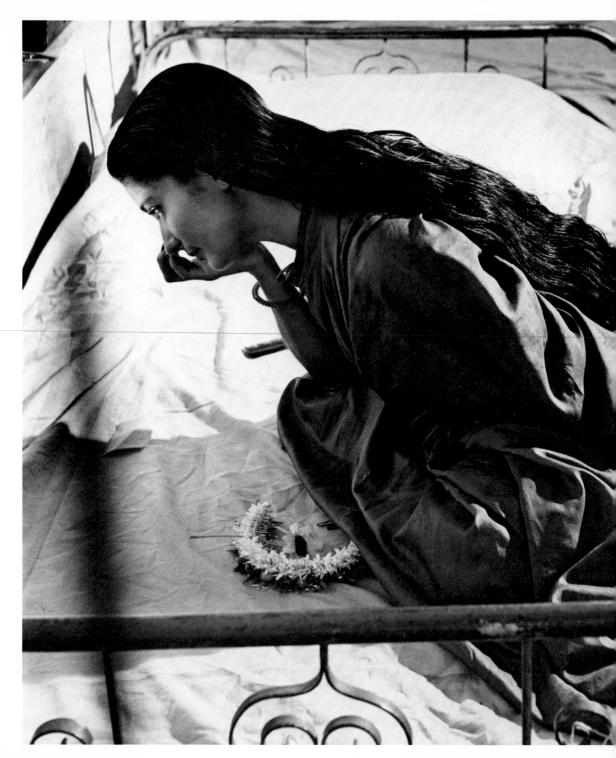

Calcutta to Tokyo June 29–30, 1951

. . . Shortly before midnight. From the misty ground a column of light rises into the sky: Tokyo airport—where night does not mean an end to work. I am sitting in a small room, waiting for them to tell us what to do next. A few American soldiers with machine guns on their backs walk through the room—they guard the planes—and then the extremely nice Japanese arrive. They are so unusually polite, and in five minutes all the formalities are over.

In the morning I go to the P.I.O./G.H.Q./F.E.C. (don't laugh—it means Press Information Office/General Headquarters/Far East Command!). A colonel gives me a friendly welcome, though the atmosphere is tense. They are planning "peace" for Korea. Everybody is hoping for an early armistice. The Americans think the Chinese losses are too great for them to continue much longer. . . .

I shall see. I received my accreditations card quickly, as well as a ration card for PX stores. Then I went to lunch at the press club with Duncan [David Douglas Duncan] and Jun Miki. I was almost happy. I arrived in Tokyo just as my "Famine" story came out in *Life International,* and everybody knew me. It is a strange feeling being alone and far away from you and all friends and then finding one's own work as a link to others. I feel so much more a part of everything. About the Japanese I cannot say much as yet. The urban architecture is horrible, so far I like the schoolgirls and the women in kimonos best. . . .

Dancer Anajli Hora
preparing for Jasmine Festival, India

JAPAN

The Ginza

Tokyo July 11, 1951

The Ginza is Tokyo's main shopping area and the big business center for
Japanese youngsters, who are trying to overcharge the GI wherever they
can. The police have no way of stopping this, and the boys will certainly
never go back to ordinary jobs. A few souvenirs, such as Japanese
embroidery or silk painting, are sold here. In the dark little side streets
the GI finds a different kind of amusement. Like spiders beside their nets,
the girls are waiting in the half-dark entrances.

On the other side, American women in Japanese souvenir jackets walk
along the Ginza. A man sells moving toys. I remember as a child I was
deeply impressed seeing the mysterious shells open up as soon as they
were put into a glass of water and a beautifully colored flower emerge from
them. Now, thirty years later, here on the Ginza, I found those magic
flowers again, unnoticed by an indifferent crowd passing hurriedly by.

Tokyo July 21, 1951

. . . The Indian Famine story really seems to be developing into the story of
the year. Capa writes that everyone is using it. It becomes clear that
important news and drama combined work best.

Tokyo September 1, 1951

. . . Yesterday was a rough day. I was invited to supper by Asahi Camera.
Big to-do: an interpreter, people with flash and cameras, professors, critics,
and stenographers—all to hear my opinions on European photography.
Three very interesting hours. And yesterday I realized, among other things,
that the painter in the photographer is frequently inhibitory—certainly in
reportage. My composing more vertically from the horizontal course of
events interrupts the continuity. While I was photographing the "Famine"
story I tried not to compose, only to catch hold as fast as possible without
conscious composition.

Tokyo November 18, 1951

Even if many of my stories are not published the way I would like them to
be, our point of view is slowly becoming a concept, and it will become
easier for us to realize our ideas in the future. I believe that only work
done in depth, with total commitment, and fought for with the whole heart,
can have any value. The details, the *"l'art pour l'art"* aperçus, are isolation
and, in a certain sense, unhealthy. Spontaneous, constant observation and
an interaction of ideas can alone relate the true situation.

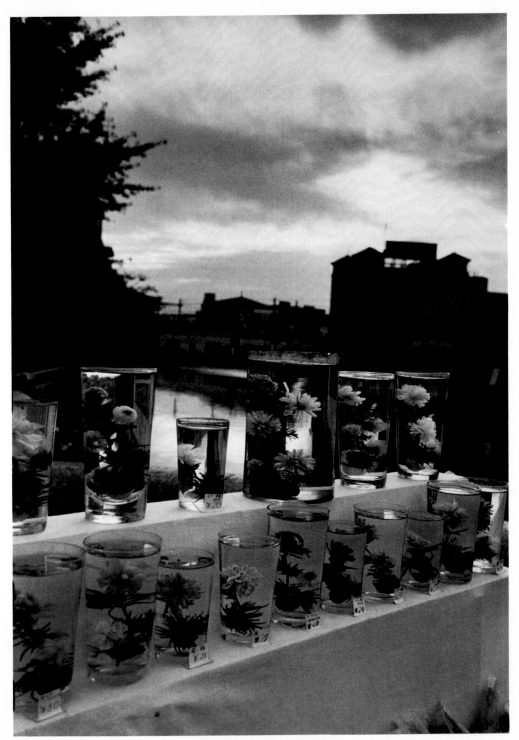

"Magic flowers" on the Ginza,
Tokyo

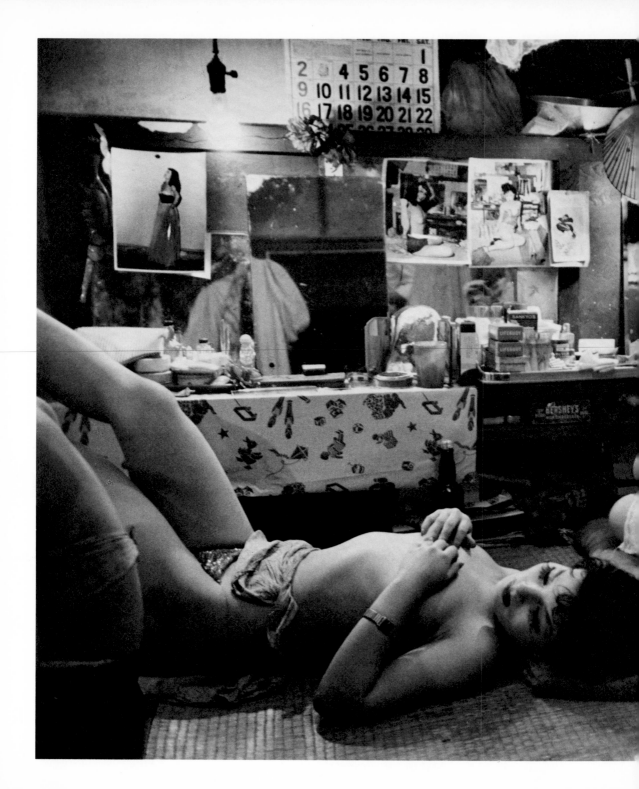

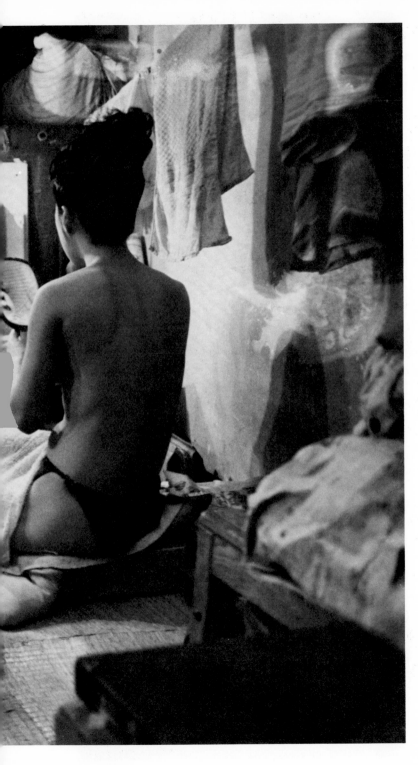

Strip-tease dancers
in their music hall dressing room,
the Ginza

Tokyo

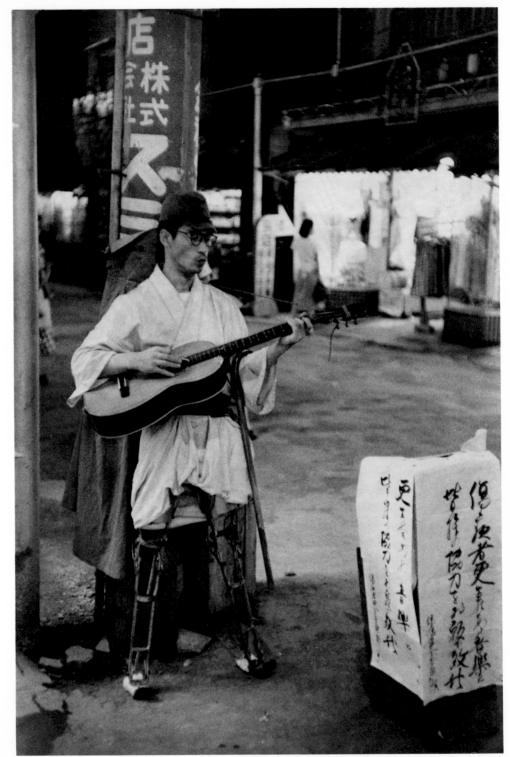

World War II veteran, the Ginza, Tokyo

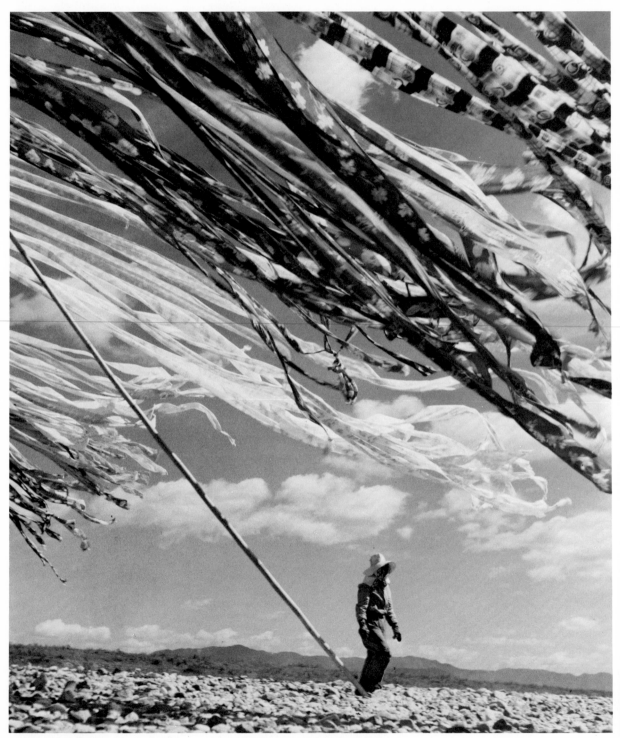

**Silk drying in the wind,
Katsura River, Kyoto**

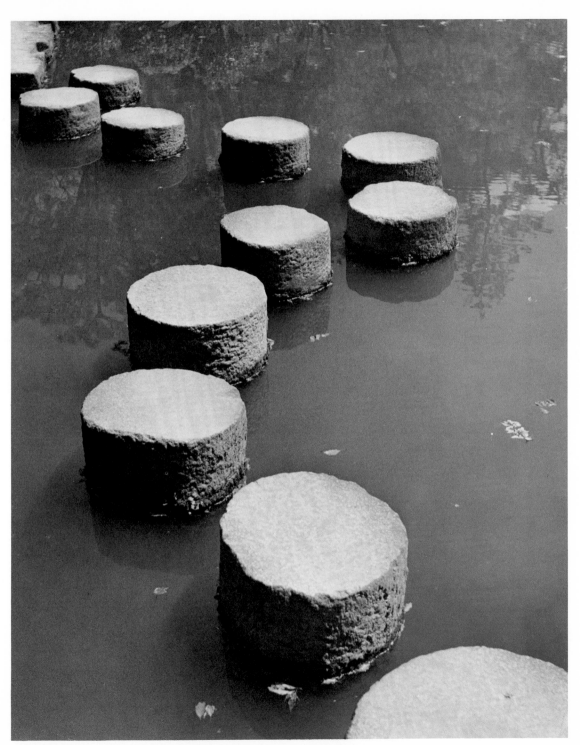

Stone path in the garden of Heian Shrine, Kyoto

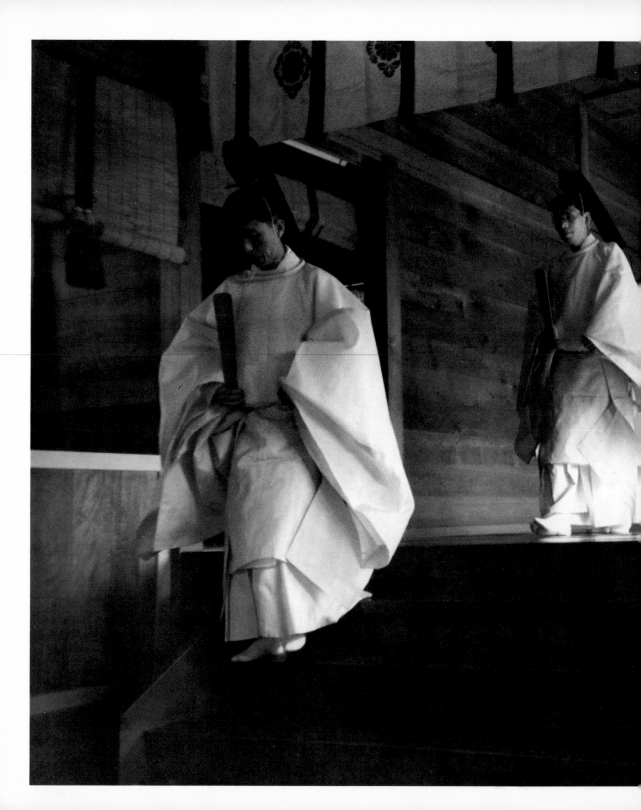

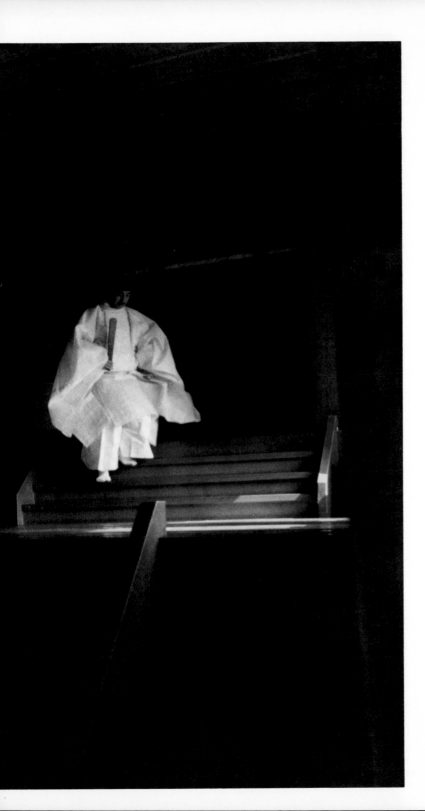

Shinto priests
Kyoto

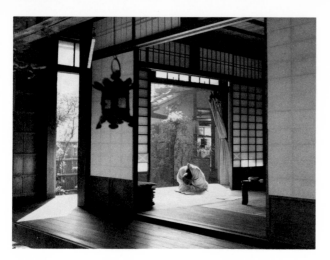

Ryoanji Temple, Kyoto

Shinto priests
in the garden of Meiji Temple,
Tokyo

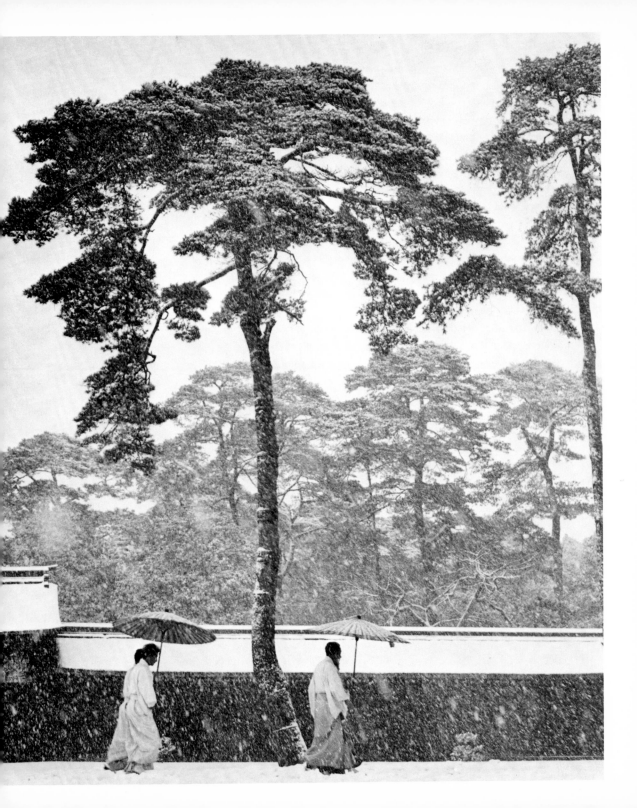

Generation X—Japanese Student

We are all too quick to condemn the postwar youth of Japan. Usually judgment is made after only a few weeks in Tokyo. We are encouraged in our views by the opinions of traditional old Japanese, who consider the postwar youth unstable and dangerous. The professors in the schools talk of their immorality, of their lack of discipline, and of the vacuum in their souls.

As a contrast to the modern business city of Tokyo, there is Kyoto, the ancient seat of the Imperial family. We know that economic circumstances lead the young to condemn that which they would never even debate on a full stomach. I am thinking of politics. Unlike Japan's traditionally carefree female youth, the young men are deeply involved with political problems. We don't know how these young people will think later on in life when they occupy leading positions, but today we can say that they are concerned with revolutionary ideas—ideas that can by no means be brushed aside as manifestations of puberty.

We say that they are on a direct path to communism. There is a grain of truth in everything, but depending on how it is viewed, every truth has a different face. These students who fill their stomachs with cheap food, who study in cold rooms, and who are stopped short when they fight for certain human rights, will one day form Japan's intelligentsia. I know that Kyoto University has long sheltered some of the most revolutionary elements and that the professors are mainly left-wing, but I also know that there are similar currents in the other Japanese universities.

Can we condemn this generation and its ideas if they do not see the necessity of self-defense for Japan? The new Japanese constitution, worked out under the supervision of the American Occupation Authorities, has a clause prohibiting Japan from rearming herself as a military power. The government, reacting to student unrest, condemns the youths and bars many from classes. But in the cellars, in the garrets, around the feebly warming charcoal braziers, the young Japanese discuss and learn, perhaps more than in official classrooms.

Tokyo December 26, 1951

To Paris Office

Dear Bob:

Many thanks for all your letters. I am sorry to say that I have to disappoint you. I couldn't make a "Christmas story" over here. Christmas doesn't exist in Japan, except in converted families.

I had some personal disappointments too, and they made it impossible for me to work.

I am very sorry that I didn't leave at the last minute and allowed myself to be detained by *Life*. Rosellina is on her way to Tokyo, as I couldn't

Generation X—a global Magnum project, in which each photographer sought out a member of the postwar generation who turned twenty in 1950. The idea was to acquaint the reader with the thoughts, attitudes, actions, and faces of the generation upon whom will rest the direction of the rest of the century. The result was published in two issues of Holiday magazine in 1952.

let her sit in India waiting for me. I am enclosing the finished Generation X story on the Japanese boy and girl. . . . If only I had had more time to work on it.

Please edit out the photographs of both stories stringently—I prefer fewer and stronger pictures.

Please send me all the Japanese stories as they are published. Could you also mail all the contacts of my Japan material? I want to put a book together and it is much simpler to work things through while I am here.

P.S.: Make a very strong editing of my pictures, I beg you.

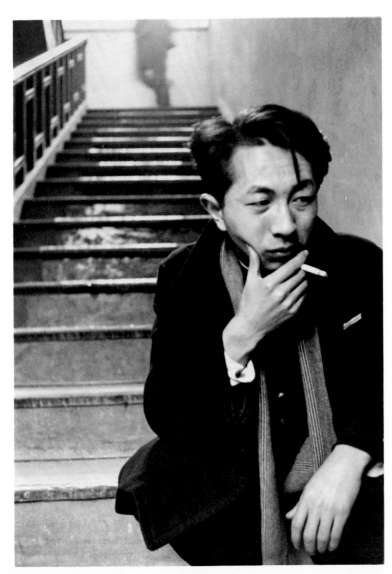

University student, Kyoto

KOREA

Tokyo July 11, 1951

. . . We were eleven correspondents from every continent flying in a four-engine plane on the fifth of July across the sea to Korea. As in all Air Force planes, we could move around freely, sit in front, and hear reports from the various stations across which we flew. After five hours we landed in Seoul and drove through the rain along destroyed roads, past pale-green rice fields, where farmers planted young seedlings at correct intervals. The sight of the town itself was as dreadful as in Germany after the war. With Asian calm the inhabitants are trying to build anew. In the midst of these ruins the only lit-up block was the press center, with hundreds of journalists. To me they seem like hyenas on the battlefield, always seeking sensationalism. But among them there were also some sympathetic, thoughtful writers, mostly French. A few women correspondents in uniform. I spent one night there with Mike Rougier of *Life*. The next day I drove with him and the press officer to the 24th Division, located in the Chunchan area, north of the 38th parallel. I have never seen anything like this: the perfect, mechanized way in which the United States conducts the war is unbelievable. We drove in a jeep for four hours toward the front; for the last two hours we haven't seen any Koreans. A zone twenty miles wide has been cleared of civilian population to facilitate military operations and to avoid unnecessary civilian casualties.

Now about my actual work here: my theme is "What happens to the civilian population in the fighting zone?" Every military unit has its own people who help the civilians. The Koreans are also involved in this as helpers and interpreters. I spoke with the colonel in charge of this department and he was very pleased that I am interested in this particular problem. Reporters usually come to Korea only in search of sensational news from the front zone, he adds cynically.

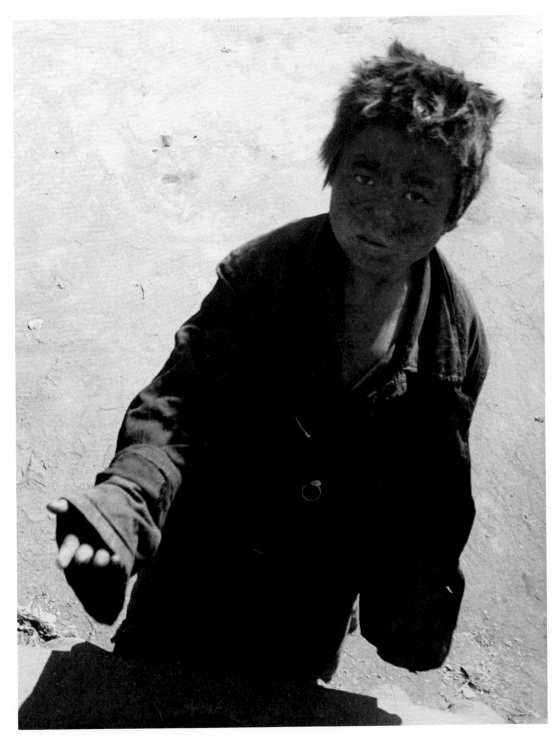

Refugee
with G.I.s
at Pusan Station

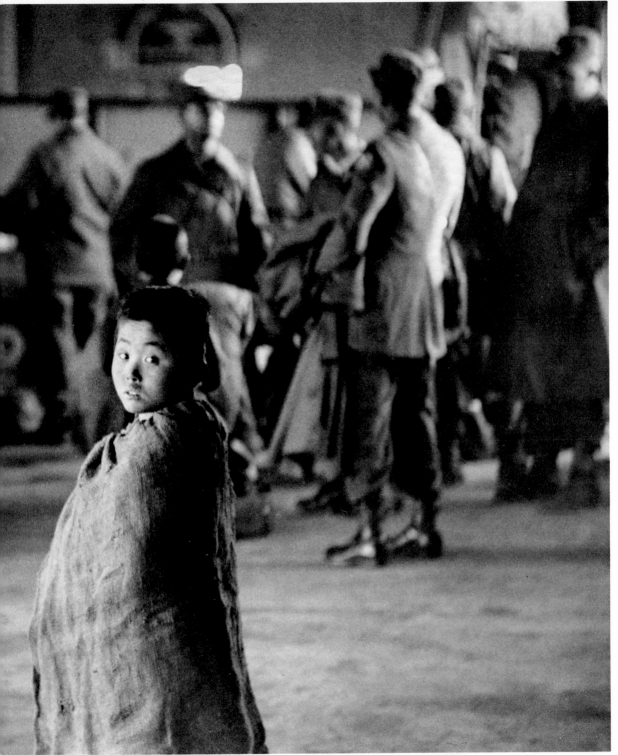

P.O.W. Camp Koje-do

January 27, 1952

. . . Today was the Chinese New Year in the Prisoner of War Camp. I spent half a day in Compound 72, where there are fifty-five hundred prisoners, ranging from fifteen to sixty-three years in age. They are pretty well dressed, some of them so well that I can hardly believe they are prisoners. However, I have a feeling that they are the showpieces of the camp and that there are darker sides to it.

Last night I saw a North Korean Compound, where some thousands of Communist prisoners are held. I also saw Communist officers, who are guarded separately, and I wonder whether these young boys are really Communists and also officers. They are sitting around helplessly, making toys out of dirt to pass time. The world seems even more crazy to me since I came to this camp. I move around the compound freely, without an armed guard—except for a public information officer who sometimes accompanies me—without remembering that they are prisoners of war. But this morning an educator was with me and we interviewed a fifteen-year-old boy. Oh, fright. I now learn that it is strictly forbidden and have to "forget" everything he told me. . . .

Tomorrow will be the turn of Compound 66, where the "dangerous" prisoners are—fanatical North Koreans, they say. I don't know whether I shall get in, as there are stringent restrictions for this compound: someone might harm me.

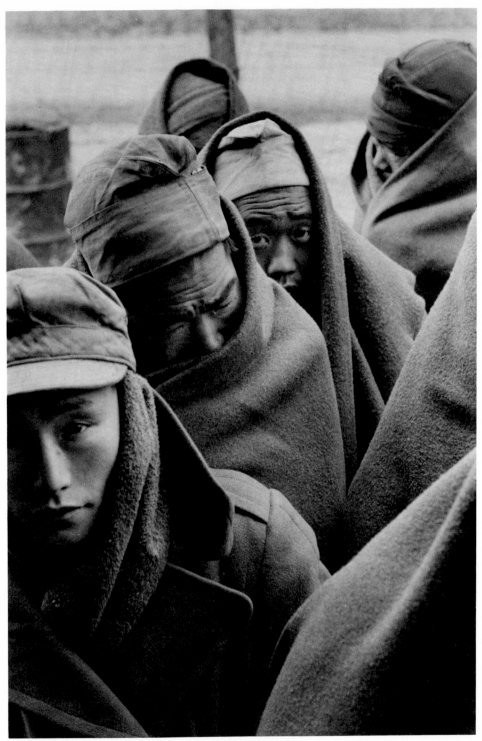

Prisoners of war,
Koje-do Camp

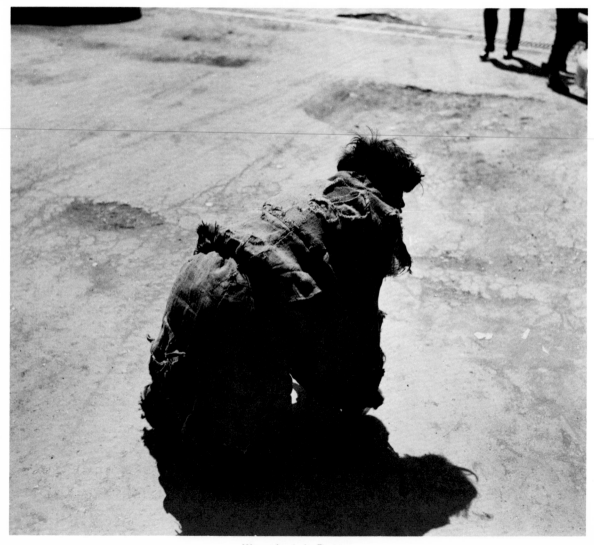

War cripple in Pusan

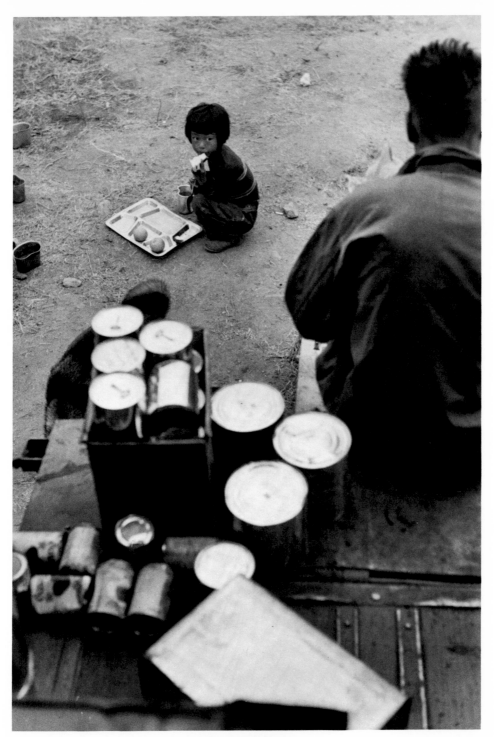

**Lunch with the G.I.s,
Korean front**

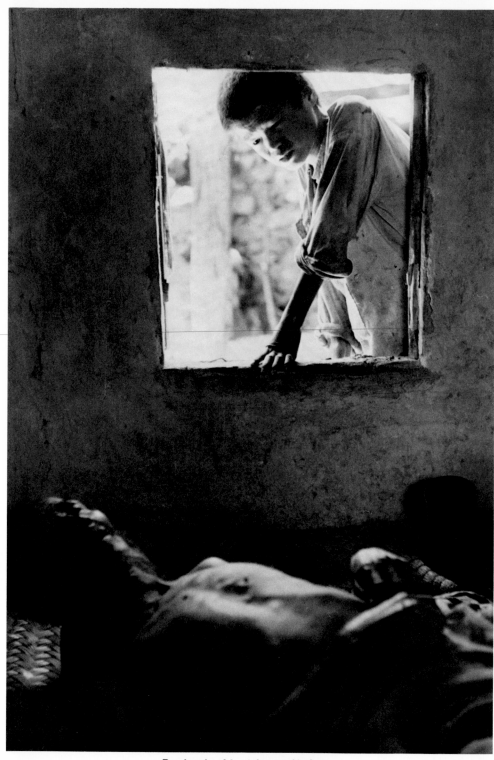

Boy leaving his sick grandfather

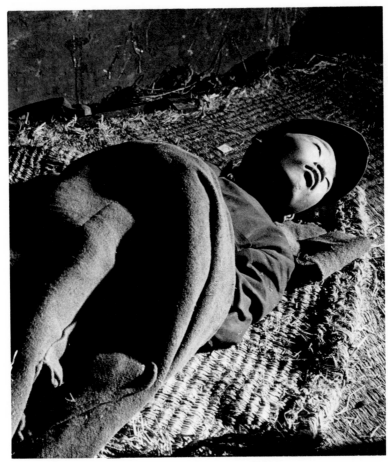

Sick war orphan in cave, Seoul

INDOCHINA

Letter from Gian Coc

Hanoi July 6, 1952

. . . I have just returned from a six-day trip that took me from outpost to outpost in the Delta. A sinister struggle is taking place out there and it seems clear to me who is winning.

We leave the Bat Nao outpost at eight in the morning. Fifteen Vietnamese accompany us, walking along the narrow ribbons of soil jutting out from waterlogged rice paddies. The peasants take no notice of us. They look very poor with their torn clothing and emaciated bodies. Alongside the fields boys fish for crabs with huge baskets. Yet this is the war in the Delta. With the peasants hoeing and ploughing, all seems peaceful in the fields. But the scene changes quickly: the peasant puts down his hoe, picks up his gun. Others follow him, and without armed protection one disappears. Whole convoys have perished like this, without a trace. We march peacefully on in the direction of the village, which is laid out like this: [sketch]. It looks altogether like a fortified town out of the Middle Ages. The gates are locked at sunset and nobody can enter.

To understand the situation in Indochina I would have to live in an outpost for some time, be part of everything, and not just pass quickly through. Five hundred souls live here: women, children, and men. They make up their own small world, each dependent on the other. It is a microcosm for study, even more so than the Chinese fishing village where I have been working.

Why this hideous war? It is clear to me that in the long run France and Vietnam are bound to lose out to the constant guerrilla warfare of the Vietminh. First of all, the Europeans are hated. This is a basic truth that no one dares to talk about as yet and that is seldom mentioned in the press. A young Vietnamese tells me that the Moroccans behaved frightfully in the villages. This is certainly only one of the reasons. The white man has had his day in the Far East. Here, he is hanging on to a sinking ship.

To summarize: we are back in the Middle Ages here. We have also retained the old system of landlords and coolies, of those who have rights and those who have none. But who would dare talk like that? The French, with few exceptions, take too much joy in the good life—the flowing wine, the girls, and the salary checks arriving regularly at the end of the month. The elite of the new Vietnam is good, but it is occupied exclusively with military problems. A stormy wind will sweep away France's colony.

Red River Delta

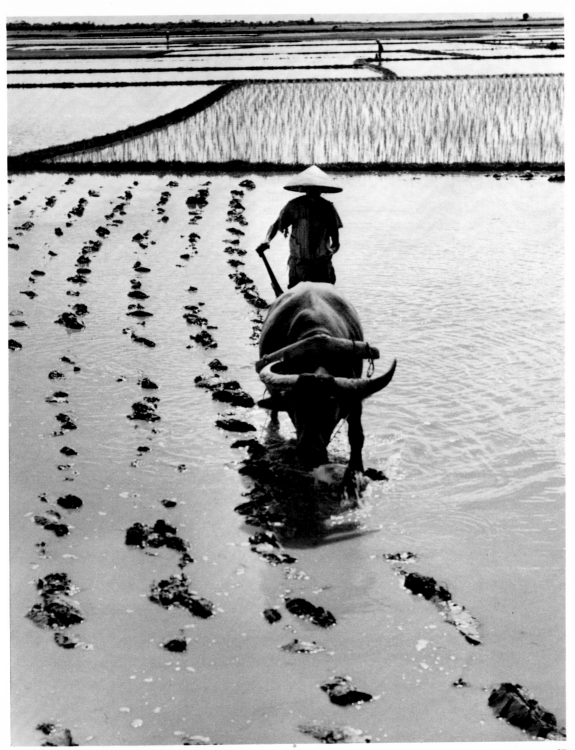

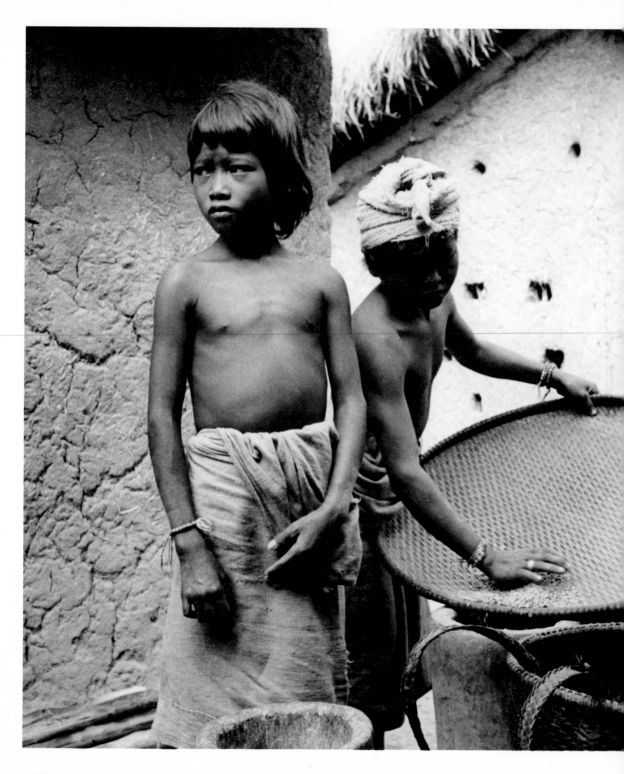

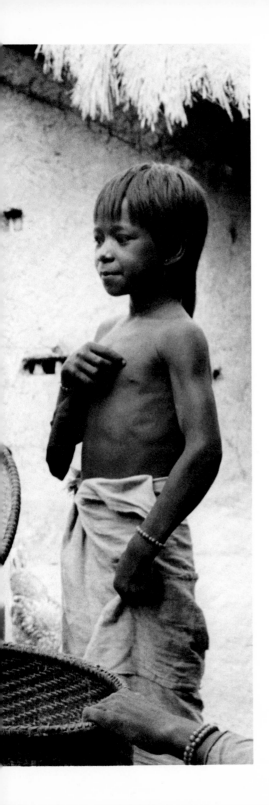

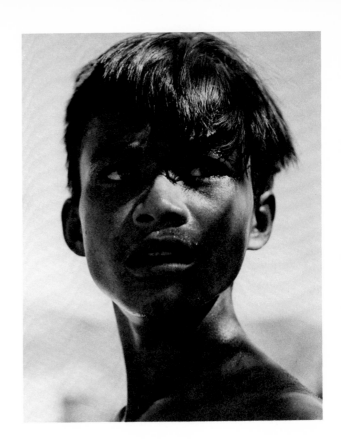

Lai chau

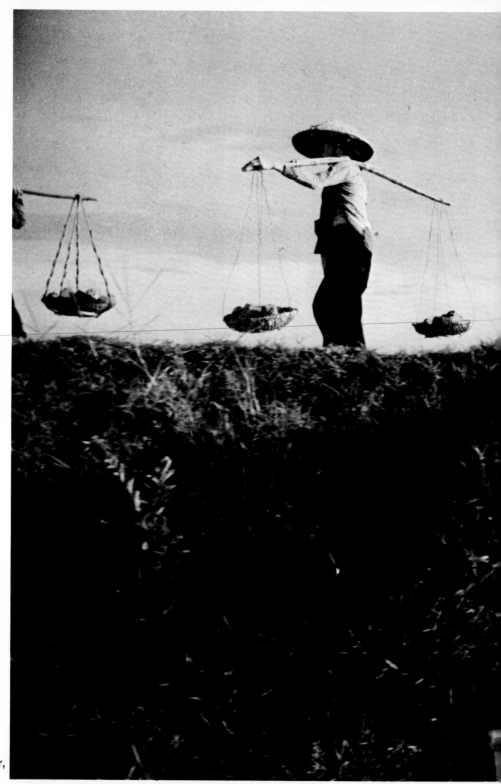

Grave of a French soldier,
Tonkin

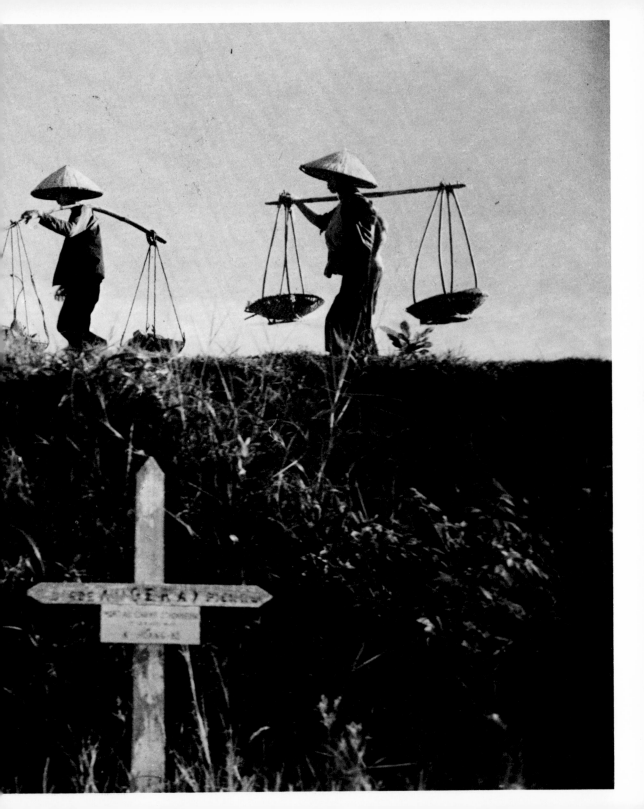

Lai Chau July 8, 1952

The plain is a mosaic of fields, of delicately colored squares—a real
Klee painting. The border fortifications look like soil thrown up by moles.
They are meant for the Chinese, who will probably invade one day. Will all
this be of much use then? I doubt it.

In the plane it is cool and I sleep a little, but then the clouds shake
up the small aircraft. We are flying quite low over junglelike mountain
ridges. It is beautiful—could be Africa or Brazil, a wild landscape. We
descend onto a bumpy grass track. Only the military welcomes us! The civilian
population flees or is disinterested. The young French counselor is peevish
with me: "Phh, what do you want here? It is raining. A tour into the hinter-
land is out of the question. You can just sit around here." I let him talk and
study him. In the end he gets friendlier, telling me that I may possibly be
able to go to Phan Tho, near the Chinese border.

July 10

As soon as the weather improves, I want to go up to that village again
and do a small story, particularly on opium. I saw how they prepare the
pipes, how they heat the small globules of opium. A man leaning over his
lamp was smoking his dose two, three, four times. This is probably one of
the very few places where opium smoking is not forbidden. Even children's
diseases are cured with opium. As a result of opium smoking, the men have
grown small and weak. The girls and women are well built and do most of
the work.

July 11–12

I went by boat across the Fleuve Noir to a little village located opposite Lai
Chau. In a big spacious house they were making cord for fishing nets.

The women of the village live apart from the men. Only once in a while a
girl appears, beautiful as a gazelle, wearing a tight jacket with silver buckles
everywhere. Carrying her little sister on her hip, she moves gracefully. I
want to go over to the women's quarters and take pictures there.

Saturday night: it is pouring dreadfully now, everything seems difficult
and I am lonely, sad, and without hope that it will soon end. All my things
are damp. The people are becoming unfriendly. They want to hide the fact
that they have concubines—because I am a journalist. Three planes flew
over but could not land and had to return to Hanoi, which has suddenly
become "our world" now that we are closed off up here. The colonel from
Alsace and a commandant have left somehow. I remain, in the rain, and I
am thinking a lot. I am drawing. Photography seems more and more

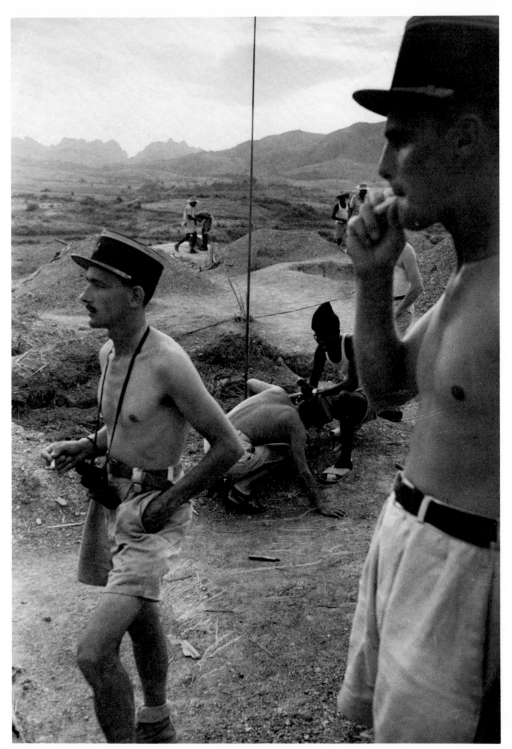

French army post,
Gian Coc

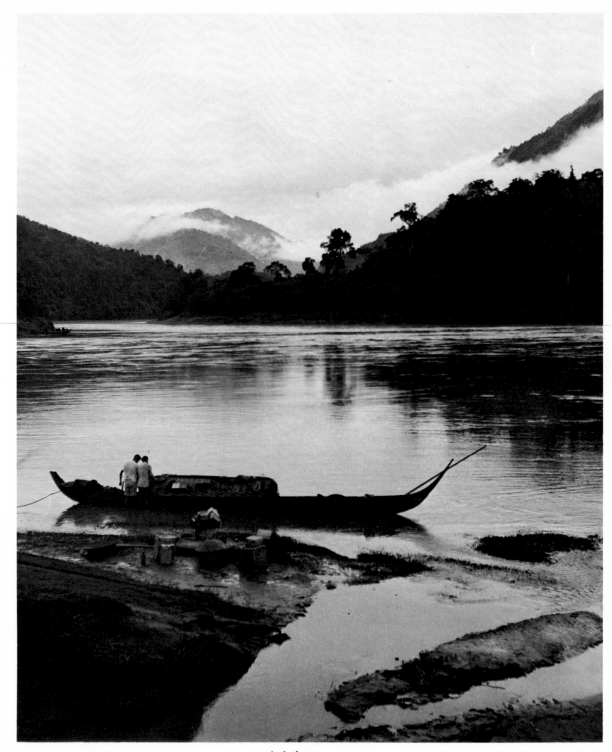

Lai chau

superficial to me, journalism a sickness, but I must carry on. The only way for me is to do books and essays like Eugene Smith's—but who gives us the opportunity for that? Or making movies, but that field, too, is incredibly corrupt. We shall see. Soon I will be home. . . .

July 18–19

Seven days since I last wrote, no planes have come. Everything is dull and silly. It is pouring buckets day and night. Everything is wet, the cheerless bed, the laundry. All my film is spoiled, the Rolleiflex is mouldy. Only my sketch pad and my health are still good.

You cannot imagine this landscape, these razor-sharp grasses, which grow over three meters tall. A path that hasn't been walked on for a while is soon overgrown.

July 20–21

Now it is ten o'clock on Monday morning, after another night in my damp bed. No hope for the next two days; it is pouring. I talked a lot with "Catherine," the C.O. of the garrison, who has spent the past fifteen years in Indochina and China. He is a plain person. Imagine, the owner of a bistro in France, a red mustache—à la Napoleon III—he is always in good spirits, corpulent but agile, and of course full of adventures and stories. For such talk and reminiscences, rain is good. How beautiful it would be if you were here, then I wouldn't mind if it rained for months. . . . I am thinking so much of you, where you might be, if you are talking with our son of our mutual experiences in the Far East. I want you so much to be happy and want to give you everything that is beautiful, but sometimes the world tears us apart. . . . We want to change all that, as soon as I get home.

I asked Chiau Pen Kam [president of the Thai Federation] what would happen if the French left. He did not give me a precise answer, naturally. It is pretty certain that the Chinese would take over the mountain territories within the year. The Thai Federation does not export. Apart from its enormously rich feudal lord, it is as poor as a mouse, and at the mercy of the North. Actually, here the Chinese have always been friends and the Vietnamese enemies. This has again been demonstrated by the fact that they have signed no treaty with Hanoi, but directly with the Emperor Bao Dai.

This war is costing France a million francs a day and so many dead. And now everyone is aware that after the last Frenchman leaves the country, Indochina will indubitably, within a short time, be ruled by the Vietminh and the Chinese. But the French officials don't like talking about this.

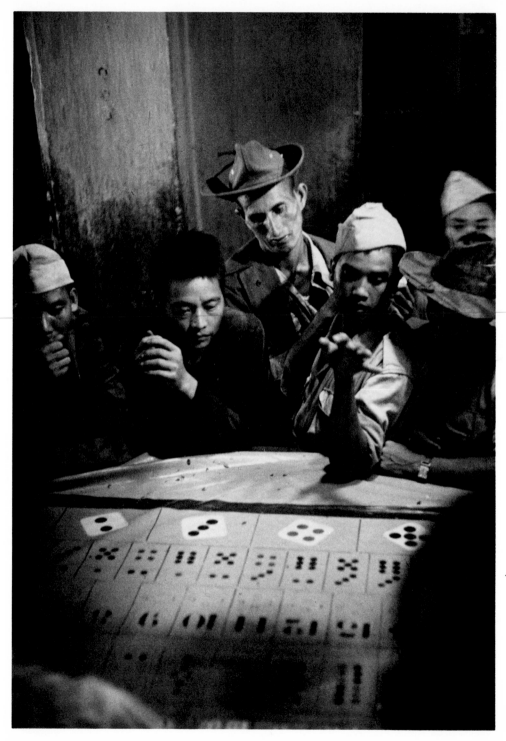

Lai chau

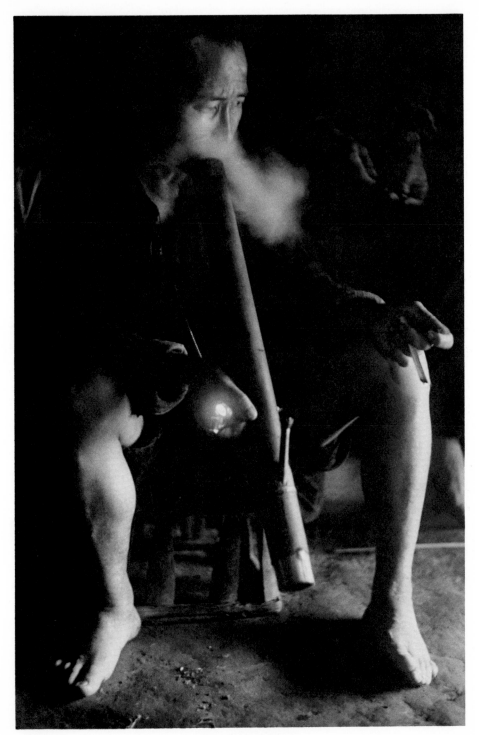

**Meo opium smoker,
Lai chau**

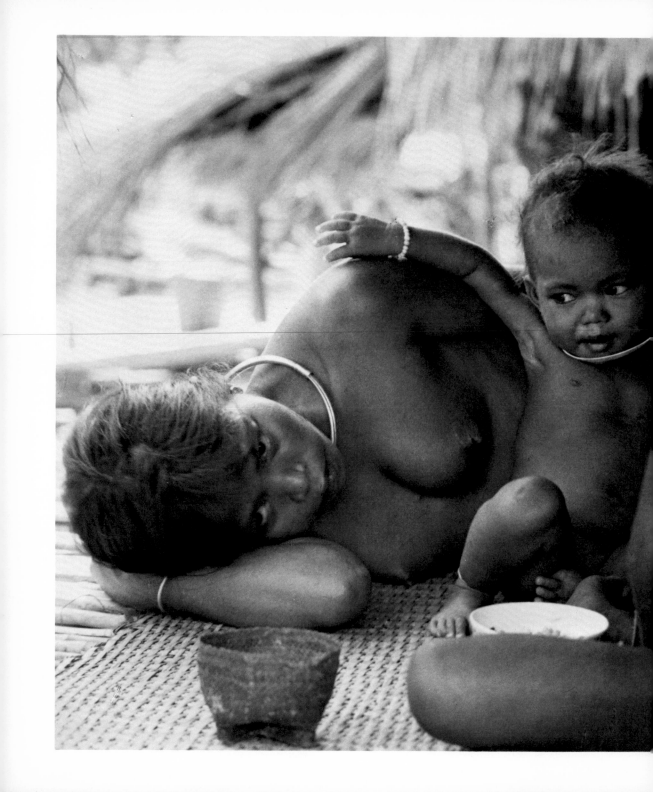

Mother and child, Ba-rau

"La Rafale" ("The Blast")

August 15, 1952

. . . I left Saigon on a train called "La Rafale," which travels through Cochinchine. What is "La Rafale"? you will wonder. It is a unit of four cars provided with its own guard. I am installed in the C.P. Car along with the second lieutenant, who is strongly against colonialism. Peculiar how many of the French talk freely when one is alone with them.

 The train has a "pilot" up front watching the tracks carefully. The mines are the most malicious part of this line. Crowds pushing at every station; baskets full of chickens, pigs, vegetables. Women and children squatting everywhere. It is barely possible to get through. We climb on the roof and run along the top of the train.

Saigon August 28, 1952

Yesterday morning at four o'clock I arrived back here, dead beat from the train trip. It took us four days to cover three hundred kilometers. Our train was held up all day long in a small railway station. The radio operator reported that the train unit from Saigon had driven into a mine.

Saigon August 28, 1952

Four o'clock, in the deep of the jungle; just as I had packed up my cameras, thinking we would soon arrive in Saigon, a tremendous explosion shook the whole train. We rode on for a few more yards and then stood still. Almost automatically after the explosion our machine guns began to fire. I quickly roll up the two armor-plated windows, take out the cameras again, and watch the reactions on the faces of the people. In front, about a hundred meters ahead of us, there is smoke. The cars stand crisscrossed. A man is hurt. The track under our car is ripped apart and below it there is a deep hole. I run across the roof into the passenger car. There, in a basket, is a little child smiling up at me. On the faces of the grown-ups is fear, but a quiet, patient fear, without hysteria. As usual, the Vietminh want to disable the engine, and again they have succeeded. With much difficulty the engine is towed away to the next station, where we wait for a new one and then drive back to pick up the other cars. Slowly, infinitely slowly, with many stops, we move toward Saigon.

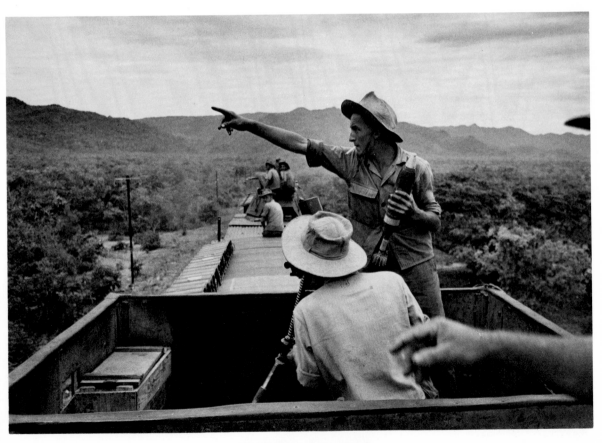

"La Rafale" under attack
en route from Saigon to Nha trang

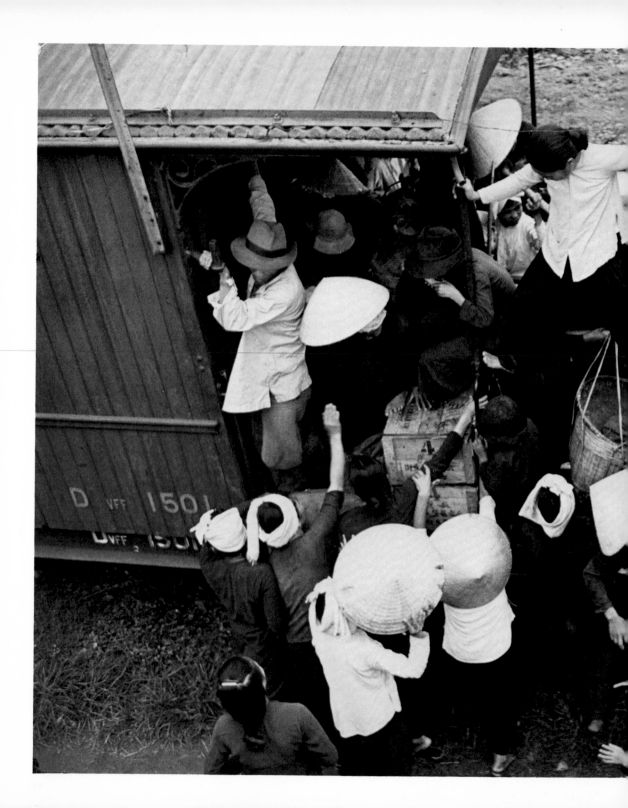

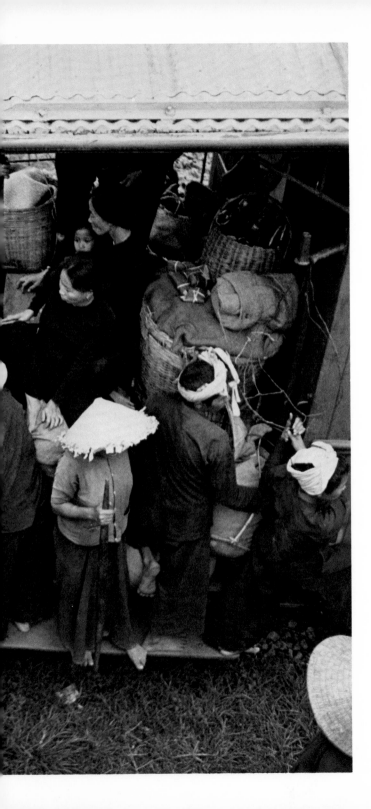

On the train "La Rafale"

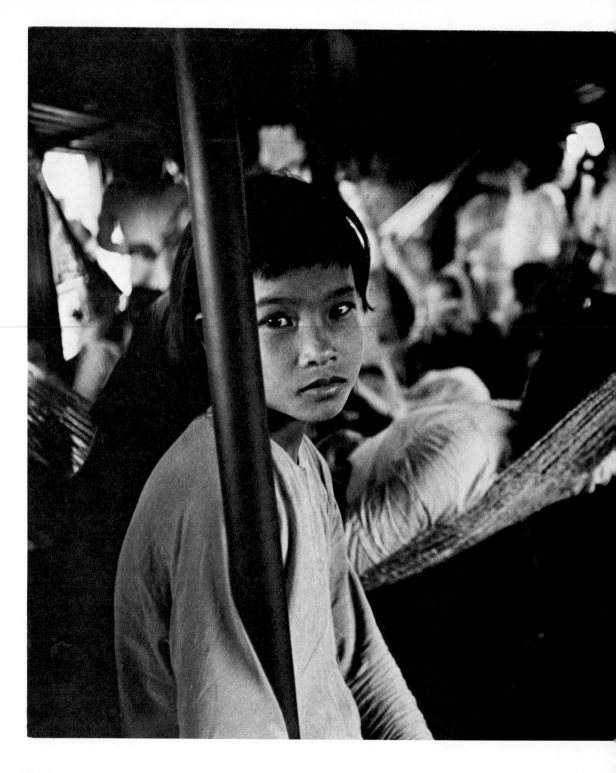

On the train "La Rafale"

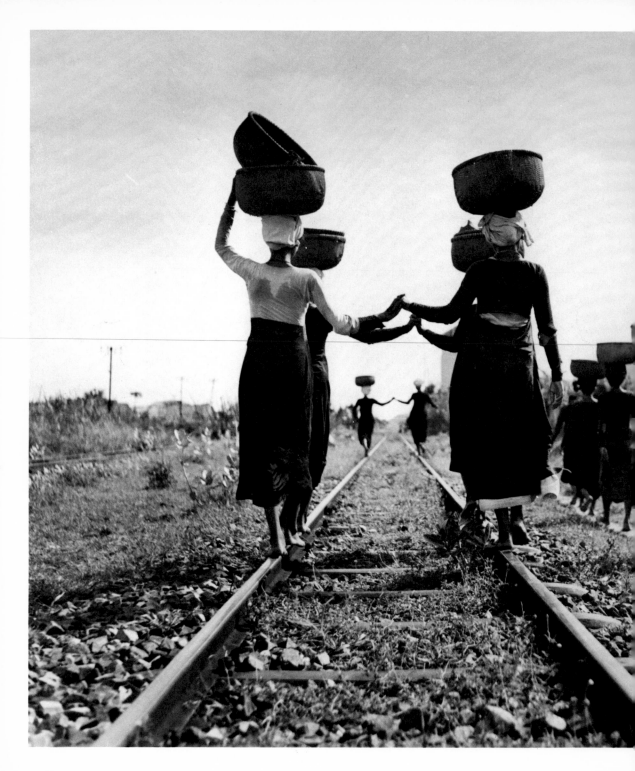

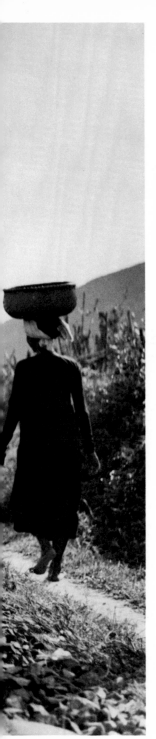

Returning from market, Ba-rau

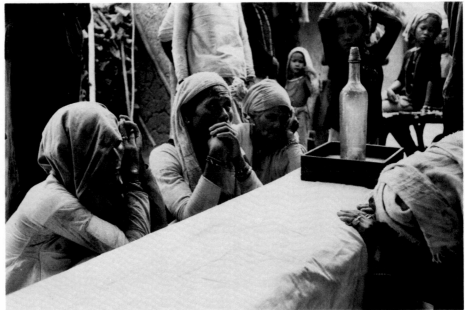

Deathwatch

PERU: THE ANDES, MELANCHOLY HIGHLANDS

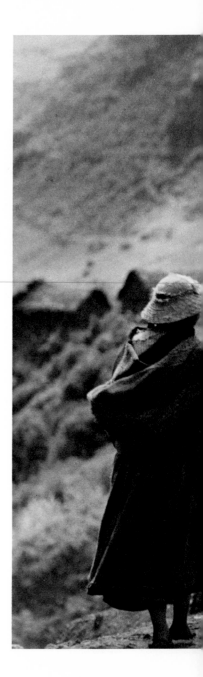

Cuzco and Pisac are the villages from which
the journey to Machu Picchu, the Inca city, begins. The colorful
costumes of the natives and their llama herds are inviting pic-
ture subjects for tourists waiting for the bus to Machu Picchu.
Posing for them is a small but welcome source of income for
the Indians. Bischof observed this with some amusement, but
not without some regret at the humiliation of a once-proud
people. Then he picked up his camera and roamed the area
around the two tiny mountain villages.

There he met a native who played his flute
as he made his lonely way down to the settlement in the valley.
Later on he met the women who drove their llamas, "walking
brown bundles of wool," to the caravansary.

The letters Bischof wrote
from this last station of his life's journey are filled with an
intense and tender sadness. And the pictures he made during
these days seem to have had as high a specific gravity as the
gold the Spanish conquistadors sent home from this region
long ago.

—Manuel Gasser, 1954

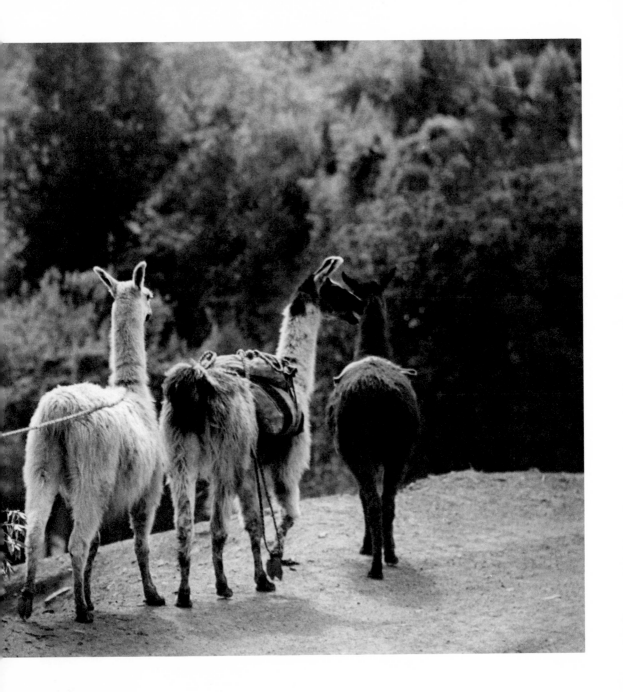

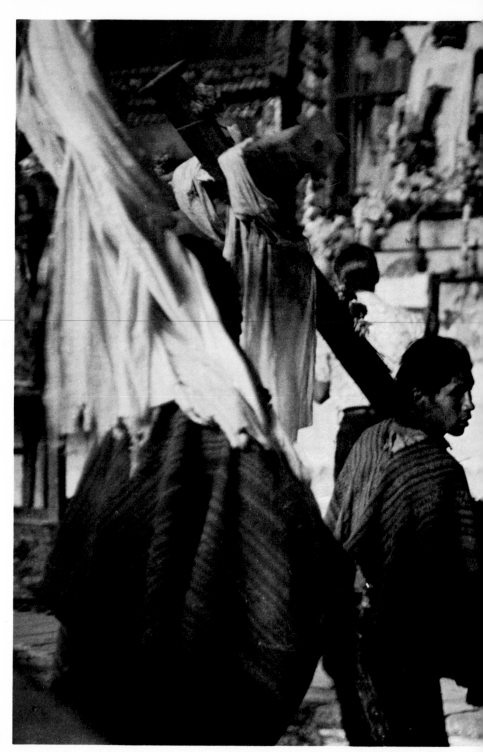

Procession,
Pisac, Peru, 1954

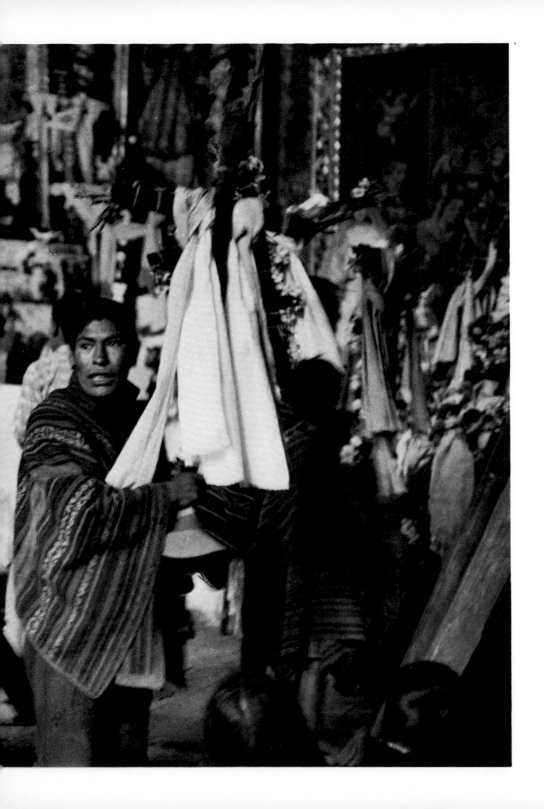

Werner Bischof
could be compared to his pictures.
He was always harmonious—with measure.
He was sensitive,
but in a virile way sensitive.
His photographs had a tendency
toward the absolute—
a combination of beauty with truth:
A stone became a world,
a child was all children,
a war was all wars.

—Ernst Haas

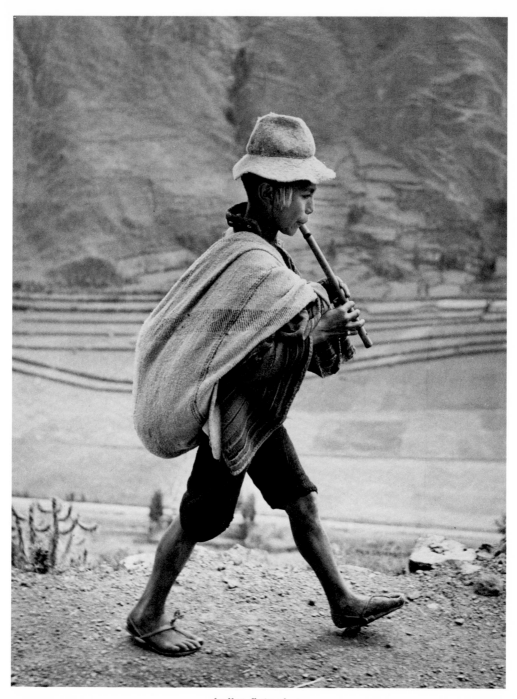

**Indian flute player
on his way to Cuzco**

He was young and tall.
He disdained conventional middle-class male attire and hated
collars; I never saw him with a hat on his head. He carried his
head high, was occasionally haughty toward the purchasers of
his handiwork—a haughtiness that arose from the earnestness
of his endeavor. He was discontent with the deportment of the
great, of the powerful, and of the reigning institutions. Demand-
ing much of our generation, he demanded as much of himself;
by means of the language of form he intended to participate
productively in the course of things. For the good of all—that's
what it was.

—Arnold Kübler, 1954

More than four years have passed
since the day the telegram from Lima arrived announcing the
death of Werner Bischof. Yet today I cannot write about him in
any other way than I would have done then: the friend whom at
one time it was my privilege to teach and who became a part of
my life. His photographs are for me the most radiant and
accomplished photographs of our time. I see him as a human
being who unremittingly molded himself in order to give what
can be given only through the mastery of the body and the
knowledge of the soul.

In spite of his
masterful technical basis, the conviction increased in him that
the development of individual human values is the indispensable
foundation for a photographic statement. The earnestness, aus-
terity, and consistency of Werner Bischof's personality, the gen-
tleness and severity, modesty and discretion that he combined
were admired by all who knew him.

—Hans Finsler, 1958

CHRONOLOGY

1916
Born in Zurich, April 26

1922
Attended primary school and Realgymnasium (high school) in Waldshut

1931
Entered the teachers' seminar at Schiers (Graubünden) to be trained as a teacher of drawing and physical culture

1932
Dissatisfied at Schiers, transferred to the Zurich School of Arts and Crafts and studied photography with Hans Finsler

1936
Following graduation with honors and after completing compulsory military training, worked as freelance photographer and graphic artist

1938
Employed at the "Graphis" Publishing House (Amstutz and Herdog), Zurich

1939
Moved to Paris with the intention of leaving photography for painting. With the outbreak of World War II, returned to Switzerland where he was at once drafted

1942
Photographs appeared in *Du* magazine; joined editorial staff of *Du* as "resident contributor"

1944
With a major essay on "Disabled People" in the April issue of *Du*, made a clear choice to become a photojournalist

1945
Traveled through war-devastated areas of France, Germany, and Holland in company of his friend and colleague Emil Schulthess. A special issue of *Du* was devoted to his coverage of "Refugees"

1946–1947
Sent on a mission through Italy and Greece by the Schweizer Spende (Swiss postwar relief organization)

1948
Photographed Winter Olympic Games at St. Moritz for *Life;* traveled through Hungary, Czechoslovakia, Poland, Finland, Sweden, and Denmark

1949
Contract with *Picture Post* and the *Observer;* joined Magnum

1950
Journey to Italy, Sardinia, Paris; worked for the Italian magazine *Epoca*

1951
Reported from the famine areas of Bihar province, India, on assignment for *Life*

1952
Traveled and photographed in Japan, Korea, and Hong Kong. Covered the war in Indochina for *Paris Match*

1953
Based on his Asiatic material *Du* published a special issue on "People of the Far East." Reported on the coronation of Elizabeth II. Went to the United States on assignment for *Fortune*

1954
Traveled through Mexico and worked for *Life* in Panama. While traveling in Peru, was killed on May 16 when his car plunged off an Andes mountain road

EXHIBITIONS

1955
Kunstgewerbeschule, Zurich, Switzerland

"Japan" (from the book),
Art Institute of Chicago, Chicago, Illinois

"Japan," second edition,
Circulated by The Smithsonian Institution Traveling Exhibition Service

1959
"Ten Years of Photography,"
George Eastman House,
Rochester, New York

1960
"Magnum, 1960," Japan

1961
"The World of Werner Bischof:
A Photographer's Odyssey,"
The Smithsonian Institution,
Washington, D.C.

1961–1962
"The World of Werner Bischof:
A Photographer's Odyssey,"
Circulated by The Smithsonian Institution Traveling Exhibition Service

1967
The Musée du Louvre, Paris, France
"The Concerned Photographer"
(one of six one-man shows),
Organized by the International Fund for Concerned Photography, Inc.,
Riverside Museum, New York

1968
One-man show, IBM Gallery, New York

1968–1969
"The Concerned Photographer,"
Tokyo and other principal cities of Japan

1969
The Smithsonian Institution,
Washington, D.C.

1969–1972
Circulated in the United States
by The Smithsonian Institution
Traveling Exhibition Service
and the International Fund
for Concerned Photography, Inc.

1969–
Circulating in Italy, Israel, Switzerland, England, and Czechoslovakia, under the auspices of The International Fund for Concerned Photography, Inc.

ARTICLES/PHOTOGRAPHS

Numerous photographs, *Du*, 1942–1944

"Disabled People," *Du*, April 1944

"Refugees," *Du*, April 1945

Report on the stud of Avenches,
Du, September 1945

Photos of war-devastated areas of France, Germany, and Holland with Emil Schulthess, *Du*, special Christmas edition, 1945, and May 1946

PERMANENT PUBLIC COLLECTIONS

Art Institute of Chicago, Chicago, Illinois

Metropolitan Museum of Art, New York

Museum of Modern Art, New York

Rose Art Museum,
Amherst, Massachusetts

Museum of Decorative Arts,
Prague, Czechoslovakia

The International Fund for Concerned Photography, Inc., New York

BOOKS

A Memorial Portfolio
Basel: Basler Druck und Verlagsanstalt,
1954

Japan, with text by Robert Guillain
Zurich: Conzett & Huber; New York:
Simon & Schuster, Inc., 1954

Carnet de Route
Paris: Edition Neuf, 1957

The World of Werner Bischof, with text by
Manuel Gasser
New York: E. P. Dutton & Co., Inc., 1959

Indiens Pas Mort, with contribution by others. Text, Georges Arnaud;
editor, Robert Delpire
Paris: Edition Neuf, 1959

Werner Bischof (a monograph),
editor: Anna Farova
New York: Grossman Publishers, Inc.
(Paragraphic Book), 1968

The Concerned Photographer,
New York: Grossman Publishers, 1968

MEMORIALS

1958-1966
The Robert Capa—David Seymour Photographic Foundation, Israel—"to promote the understanding and appreciation of photography as a medium for revealing the human condition." The foundation aims also to improve relations among all peoples and to foster international cooperation through the means of photography. Awards are given yearly to photographers whose works seem most in the tradition and spirit of Capa and Seymour.
Incorporated into ICP [see below].

Established 1966
ICP—The International Fund for Concerned Photography, Inc. (formerly the Werner Bischof—Robert Capa—David Seymour Memorial Fund)—"to foster the ideas and professional standards of these three men who died a decade ago while on photographic missions." The Fund seeks to encourage and assist photographers of all ages and nationalities who are vitally concerned with their world and times. It aims not only to discover and help new talent but also to uncover and preserve valuable and forgotten archives and to present such work to the public.